MW00990074

IMAGES
of America
VIRGINIA'S
PRESIDENTIAL
HOMES

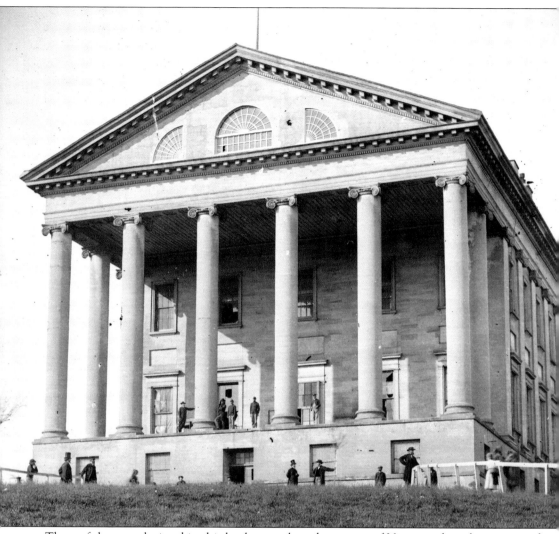

Three of the men depicted in this book were elected governor of Virginia when this version of the Virginia Capitol stood high on the hilltop above the James River in Richmond. The author, Patrick O'Neill, conducted an archaeological investigation at the capitol and found the original 1786 foundation, which Thomas Jefferson actually had the construction crew remove because they were building the walls too wide for his specifications. (Library of Congress, Prints and Photographs Division.)

ON THE COVER: Monticello was designed and built by Virginia-born Thomas Jefferson, author of the Declaration of Independence and the third president of the United States of America. (Library of Congress, Prints and Photographs Division.)

IMAGES
of America

VIRGINIA'S
PRESIDENTIAL
HOMES

Patrick L. O'Neill

ARCADIA
PUBLISHING

Published by Arcadia Publishing
Charleston, South Carolina

Printed in the United States of America

Library of Congress Control Number: 2010921013

For all general information contact Arcadia Publishing at:
Telephone 843-853-2070
Fax 843-853-0044
E-mail sales@arcadiapublishing.com
For customer service and orders:
Toll-Free 1-888-313-2665

Visit us on the Internet at www.arcadiapublishing.com

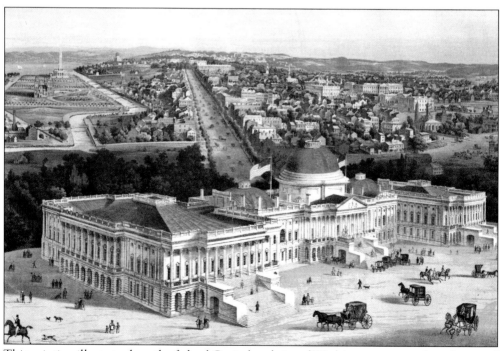

This painting illustrates how the federal Capitol and city of Washington appeared on the eve of the Civil War. (Library of Congress.)

CONTENTS

ACKNOWLEDGMENTS

Like most authors before me, I would like to thank a host of people who made this book a reality. These people and their groups were instrumental in the successful completion of *Virginia's Presidential Homes*: Lucy Lawliss, Phillip Greenwalt, and Rijk Morawe from the George Washington Birthplace National Monument; Laura Galke and Paula Raudenbush from the George Washington Foundation and Ferry Farm; Leslie Barker of Queensbury, New York; the staff of the Prints and Photographs Division, Library of Congress; Jeanne Stalker and E. Lisk Wycoff Jr. of the Homeland Foundation, Amenia, New York; William Thomas of the James Monroe Memorial Foundation; Cindy Dauses of the Archeological Society of Virginia, Kittiewan Plantation; Dale Neighbors of the Special Collections, Library of Virginia; David Voelkel and Carolyn Holmes of Ashlawn/Highland Museum; Mark Wenger, John Jeanes, Elizabeth Loring, Matt Reeves, and Gillian McGuire from the Montpelier Foundation; Jennifer Belt and Robin Stolfi from the Museum of Modern Art, New York City; the Orange County Historical Society, Orange, Virginia; the National Portrait Gallery; Ridgely Copland, owner of North Bend Plantation; Harrison Tyler, owner of Sherwood Forest Plantation; the Thomas Jefferson Foundation; Quattro Hubbard of the Virginia Department of Historic Resources, Richmond; and Peggy Dillard and all the interns at the Woodrow Wilson Presidential Library, Staunton, Virginia. Elizabeth Bray from Arcadia Publishing was a joy to work with on this project. Much to his surprise, I would like to extend a special thank you to Lynn Moore for all he has done for me, allowing me so much freedom from work. Finally, I would like to extend my unending love and gratitude to my wife, Diane, and the girls, Bridget and Lizzie, for letting me hog the computer and go gallivanting off on the quest for a photograph or fact. This book is dedicated in memory of my sister-in-law, Marie K. Schug (1963–2009).

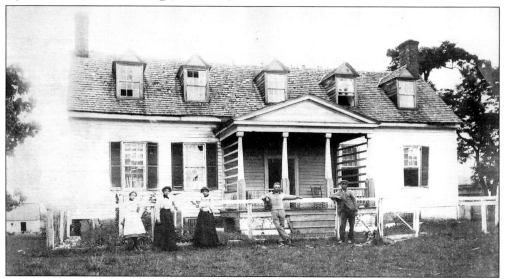

Kittiewan Plantation, in Charles City County, Virginia, is the home of the Archeological Society of Virginia and the Virginia Archeology Research Center (VARC). As president from 2009 to 2010, I was happy to include archaeological finds into this book. Archaeology releases the past from the purgatory of time. (Kittiewan Archives.)

INTRODUCTION

Eight significant men have two special connections in the hall of the history of the United States of America: George Washington, Thomas Jefferson, James Madison, James Monroe, William Henry Harrison, John Tyler, Zachary Taylor, and Woodrow Wilson. The first connection is their birth state—not of their own choosing, but rather by the choosing or happenstance of their parents. They were all born in Virginia, the "Mother of Presidents": five when Virginia was a British colony, one during the American Revolution, one just after statehood (Virginia retained her commonwealth status), and one on the eve of the Civil War.

The second connection these Virginia-born men share is they all became a president of the United States, the highest and most powerful position in the nation and perhaps the world in modern times. No other state in the union can boast such a claim, although Ohio considers itself to be the mother of eight presidents, too. Eight presidents have actually lived in Ohio, but Ohio has forgotten that William Henry Harrison was born in Virginia, which would bring their total to seven natural-born presidents.

Several of these men were distantly related to each other, some more closely than others, as Madison and Taylor's fathers were first cousins. Three sets of two of these men were born within 10 miles of each other: Washington and Monroe, Madison and Taylor, and Harrison and Tyler. Three men, Jefferson, Madison, and Monroe, became good friends, sharing their political ideas with each other; Monroe even moved to be a neighbor of Jefferson.

There are many more sets of facts distinguishing these men from the rest of the presidents. Each of these eight developed their political ambitions in a different way. Some were born into a strong, politically active family, such as both Harrison and Tyler; others, like Jefferson and Madison, were well educated at a young age, which perhaps opened their minds to broader knowledge of the world. Washington and Jefferson served in the Virginia House of Burgesses prior to the American Revolution. Jefferson, Monroe, and Tyler were governors of Virginia, with Monroe even elected in two separate periods. Taylor won several battles during the Mexican-American War, and his popularity alone enabled him to become the first president never to have held prior public office.

These men served on a national level, too, as ambassadors (Jefferson, Monroe, and Harrison), senators (Monroe, Harrison, and Tyler), representatives (Madison, Harrison, and Tyler), secretary of state (Jefferson, Madison, and Monroe), secretary of war (Monroe, while also secretary of state), and as vice president (Jefferson and Tyler).

With the exception of Wilson, the Virginia-born presidents all served in the military in some capacity, spanning from the French and Indian Wars in the 1750s to the Mexican-American War in the late 1840s. Some were only local militia, such as Jefferson and Madison. Washington was first in the Virginia militia, then joined the Virginia Regiment as a professional soldier, and finally led the Continental Army. Others were regular army, such as Tyler, "Old Tippecanoe" Harrison, and "Old Rough and Ready" Taylor.

Farming was the most common denominator between these men, again with the exception of Wilson. The farms ranged from a few hundred acres to several thousand acres, with the understanding that only through cultivation came profit and prosperity, since the United States lacked the industries of Great Britain and Europe until the mid-19th century. However, the plantation mentality came at a price. All of these farmers-turned-president owned slaves, and Harrison was the only one not to own slaves by the time he was elected president. Only Washington released his enslaved servants after his death.

All of these eight men married. The spouses of Tyler and Wilson, sadly, died while they were in office, and both of these men remarried before they left office. Two of the eight, Washington and Madison, never had children, although each married widows with children whom they raised as their own. Each of the remainder of the eight had several offspring, with many dying in infancy, typical of the period. Tyler had 15 children from two marriages, the most of any president.

The first president to die in office, Harrison, was Virginia-born, and the vice president to succeed him, Tyler, was Virginia-born. The second president to die in office, Taylor, was also born in Virginia. Jefferson died on July 4, 1826, on the 50th anniversary of the signing of the Declaration of Independence he authored, and his very good friend James Monroe died on July 4, 1831. Taylor became fatally sick on July 4, 1850, but did not die until July 9.

Washington was a successful plantation owner, a great military man, and a natural-born leader. Yet his farm suffered from neglect when he was president, and he wanted to sell all but his beloved Mount Vernon, but he did not. Jefferson, Madison, and Monroe built lavish homes and accumulated thousands of dollars in debts, generally centering on their desire to entertain and live a style they thought a president should live but could not maintain. Only Monroe had to sell his property before he died, but the heirs of Jefferson and Madison did so soon after their deaths.

Where did these eight men live, and where did these happenings just described take place? In what type of home were they born, and where did they grow into adulthood? How did they express themselves in residential status once their adult lives were in place and their political paths took them toward the White House and presidency? Did their homes reflect a change?

This book presents the major residences of the eight Virginia-born presidents, including their birthplaces, homes from their adult lives, and many of their burial locations. None of these men were born in a three-sided log cabin like Lincoln, although Old Tippecanoe Harrison was supposed have been born in a log cabin, if his campaign told the truth. Harrison was, in fact, born in the impressive Berkeley Plantation.

The Virginia homes of these presidential men, their wives and first ladies, their children, and family life are chronicled through a rich visual history of photographs, portraits, paintings, and drawings. The historic landscapes they sought as retreats, entertainment centers, fortresses of solitude, or places of the humble beginning of life, and the reader will indeed see where George Washington slept.

One

GEORGE WASHINGTON

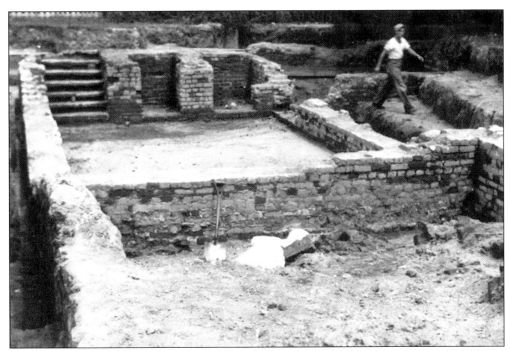

George Washington, the first president of the United States, was born on February 22, 1732, to Augustine and Mary Ball Washington at their home on Pope's Creek in Westmoreland County, Virginia. He had four half-siblings from his father's first marriage and was the oldest of five siblings by the second marriage. Archaeologists uncovered the remains of Washington's birthplace in 1930, with additional excavations in 1936 and 1974. (GWBNM.)

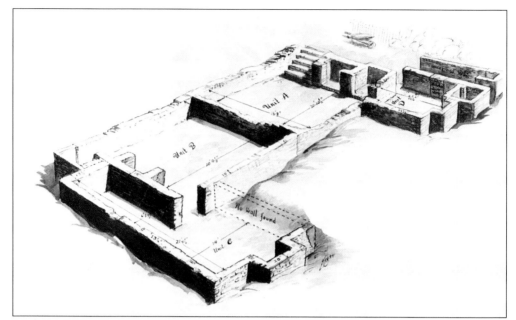

Washington's birthplace burned on Christmas Day, 1779, when he was 46 years old, and no drawings or paintings exist showing the building. In 1815, his step-grandson George Washington Parke Custis placed a stone, which was later lost, near the site. Archaeologists found a brick foundation for two rooms with a chimney at each end. Probably a 1.5-story structure, the wings were added after Washington was born. (GWBNM.)

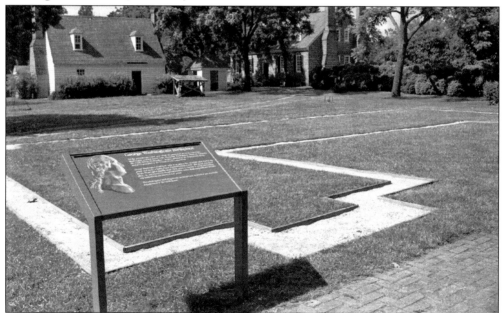

In 1738, the Washington family moved close to Fredericksburg, and the land was later sold. Virginia acquired the birthplace property prior to the Civil War, and the land was then purchased by the United States in the 1880s. The National Park Service became the administrator of the property in 1932, the bicentennial year of Washington's birth. The foundation is now outlined with oyster shell and interpreted with recovered artifacts. (GWBNM.)

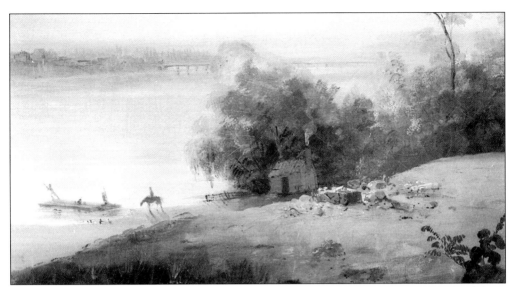

Washington's family moved to the northeast bank of the Rappahannock River near Fredericksburg in 1738 to a place later called Ferry Farm. His father was a farmer, a manager, and held political office. Washington received his primary education there, but his father's early death in 1743 kept him from being educated in England. The remains of the house by the bluff overlooking the river are shown in this 1833 painting. (HF.)

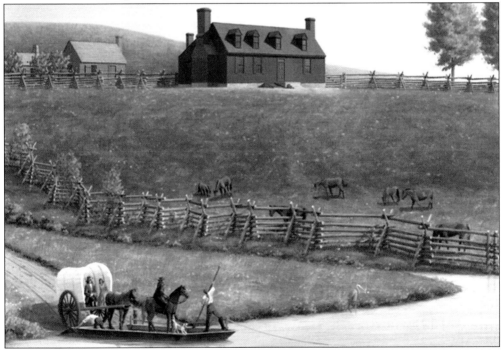

Washington learned to farm and survey at Ferry Farm. His mother managed the farm until he was of age, and she moved to Fredericksburg in 1772. If young Washington did cut down a cherry tree, as the fable says, it would have been at Ferry Farm. This conjectural painting utilized current archaeological findings, historical documentation, and existing 18th-century buildings to develop a realistic view of the house and landscape. (LB.)

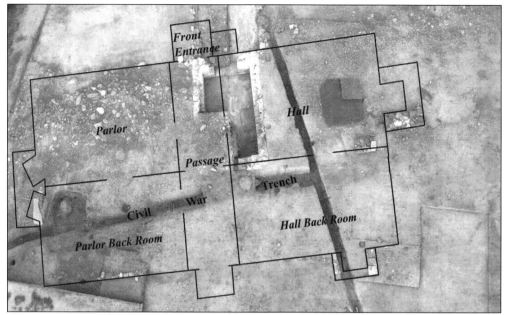

Ferry farm is owned by the George Washington Foundation, which sponsored archaeological investigations locating the remains of the Washington house in 2008. Artifacts and features indicate the 1.5-story frame house was 54 feet long. Two chimney bases, two well-crafted stone-lined cellars, and two root cellars were found. Thousands of recovered artifacts related to the Washingtons' ownership, including a spur that may have belonged to one of the Washington boys. (GWF.)

The property containing Mount Vernon was Washington's ancestral land. The original patent for the tract was received by his great-grandfather John Washington and Nicholas Spencer. The two split the neck of land between Dogue and Little Hunting Creek, with Washington keeping the portion where Mount Vernon is located. It was passed down through the generations; Washington's older half brother Lawrence passed it on to him when he died in 1752. (HABS/LCPP.)

Washington never received a formal education, but he did not let it impede his personal growth. He became a surveyor in his teens, rose to a colonel during the French and Indian War, was elected to the House of Burgesses, and became a farmer, all by 1758. He wanted to develop Mount Vernon into a grander plantation, but he had no collateral and had not yet married. (NPG.)

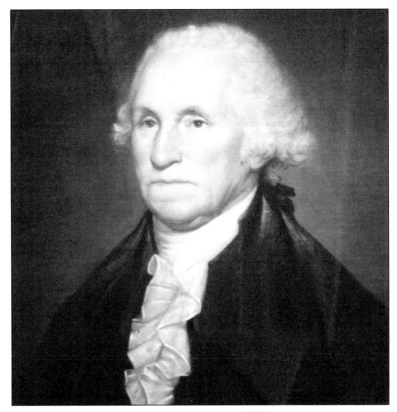

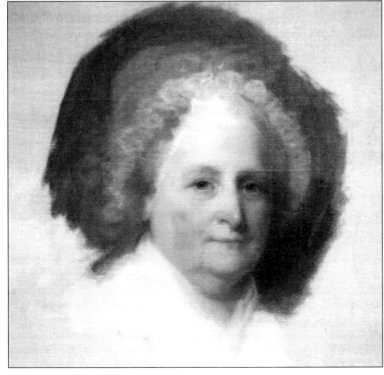

Martha Dandridge was born in 1731, slightly before Washington. She married Daniel Parke Custis in 1749, and to this union was born four children, with only John (Jacky) and Patsy living to adulthood. When Custis died in 1757, she became a much-sought-after widow with a substantial estate and capital. Washington met Martha, and within a few months, they were engaged, marrying on January 6, 1759. (NPG.)

13

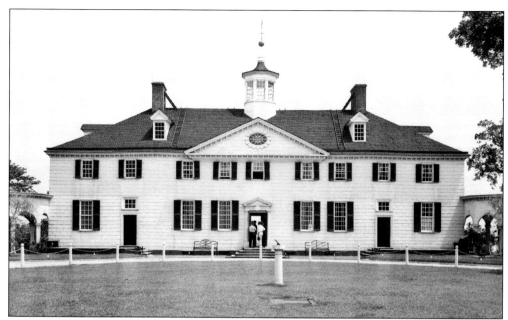

Mount Vernon was only a 1.5-story wood-frame home when Washington received it from his brother. The year before he married Martha, he raised it a full story, but it was still contained within the breadth of the two exterior chimneys seen here. The cupola and side additions extending beyond the chimneys were added by the mid-1770s. Washington spent almost four decades building Mount Vernon to his specifications. (HABS/LCPP.)

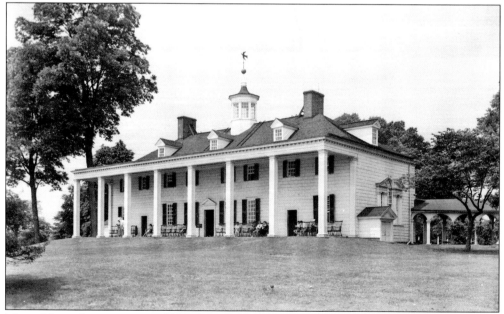

Mount Vernon's most recognizable feature is perhaps the two-story piazza extending the length of the final version of the mansion. Completed by 1777, the feature has eight wooden, Tuscan-style piers with a low-pitched roof covered with lead-coated copper. The piazza floor was paved with white English flagstones. The piazza was completely replaced in 1860, the pillars in 1894, and some flagstones in 1997. (HABS/LCPP.)

Washington did not have the finances or the ambition to build a brick mansion at Mount Vernon. He was content with expanding and modifying the existing wood structure. He did, however, want to enhance the exterior and used a process he had seen on several mansions in New England called rustication. Wood planks were carved and painted with a sandy mixture to look like painted stone blocks. (HABS/LCPP.)

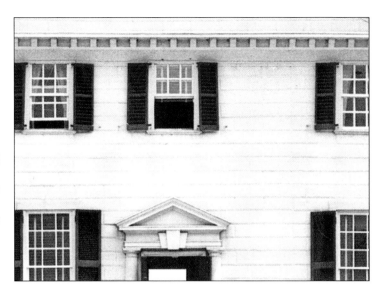

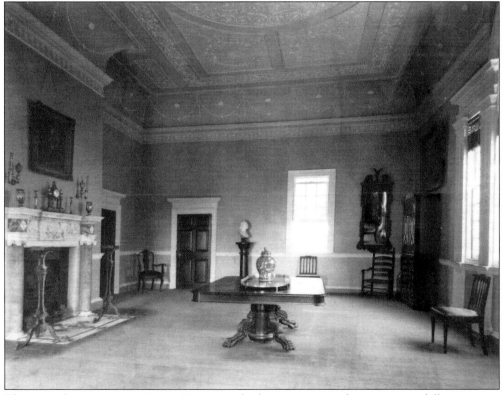

The main dining room at Mount Vernon is the largest room in the mansion, a full two stories tall. The ceiling was decorated with plaster ornamentation of crops and farming tools, and the walls were adorned with landscape paintings chosen by Washington himself. In this room, Washington was informed he had been elected president in 1789, and it was also in this room where Washington was laid after he died in 1799. (LCPP.)

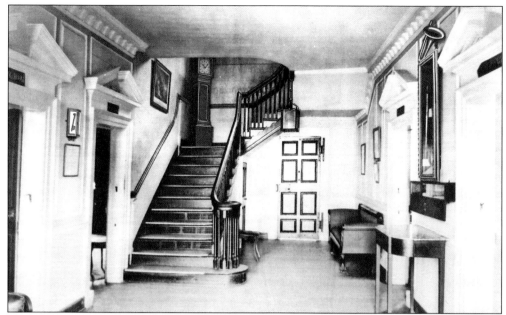

The central hallway functioned as a location for entertaining guests, taking advantage of the cool breezes from the open doorways. When Washington enlarged the house in 1759, he added the elegant black-walnut handrail and walnut staircase, which offset the symmetry of the windows from the west side of the home. The raised pine paneling was grained in 1797 to imitate expensive mahogany. (LCPP.)

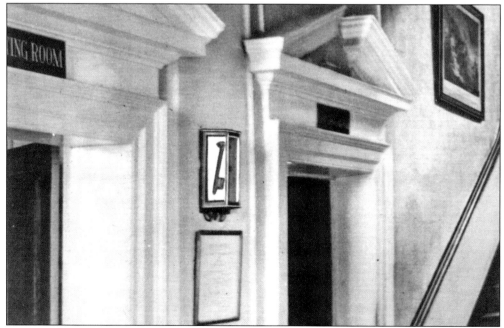

The key to the west portal of the Bastille in France was sent to Washington in 1790 as a symbol of liberty by General Gilbert, Marquis de Lafayette, who served under Washington in the American Revolution. The Bastille was used as a political prison for many years, and when it was stormed in 1789, this marked the beginning of the French Revolution. (LCPP.)

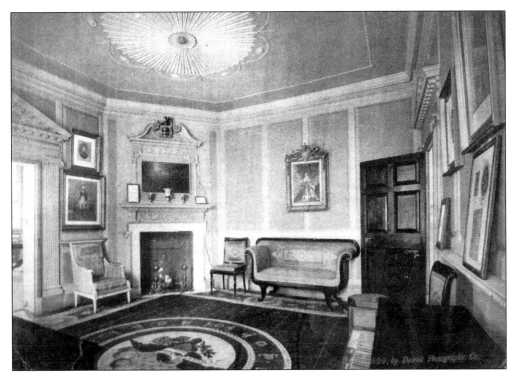

The front parlor was an elegant room where guests enjoyed the company of the Washingtons. Tea and coffee were usually served here during the winter months. The family also gathered here in the evenings to read and discuss the latest political news. The carved mantel, two Palladian doorways, and paneling enhanced the walls. The Washington family coat of arms is carved into the mantel, with the family crest on the fireback. (LCPP.)

The small family dining room was part of the original 1730s house and served as the main dining room before the larger dining room was added. Master craftsmen were employed to create the ornate wood carving above the fireplace and the plasterwork on the ceiling. In 1785, vivid verdigris paint was added, as Washington believed the color was less likely to fade and was pleasing to the eye. (LCPP.)

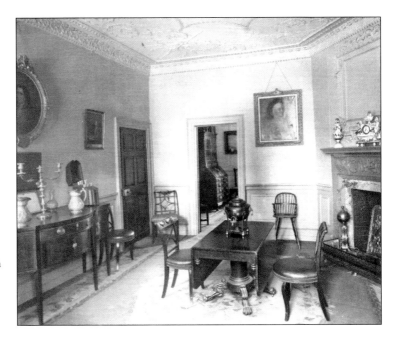

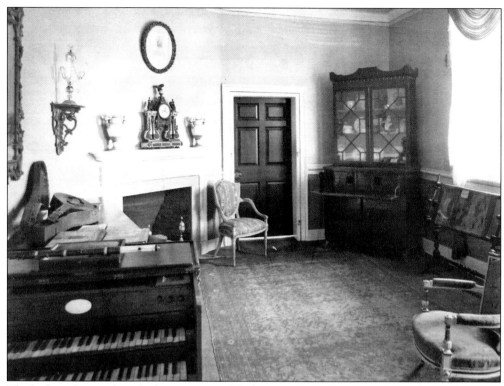

The little parlor, used as a bedroom prior to Washington's retirement, was located near the piazza and nestled between the large dining room and entrance hall. Washington purchased musical instruments for Martha's two children, Patsy and Jacky. For Jacky's daughter Nellie, Washington purchased a fine harpsichord and the English guitar seen resting on top, the reason the room is sometimes referred to as Nellie Custis's music room. (LCPP.)

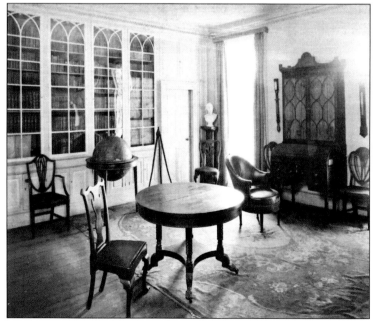

Washington's library was his retreat when he needed to read or write his numerous correspondences. He rose daily between 4:00 and 5:00 a.m. and went down the private staircase to the study. In the evening, unless he had lingering guests or social obligations, he would return to his study to read or have discussions with his manager, retiring around 9:00 p.m. No one was allowed in without specific invitation. (LCPP.)

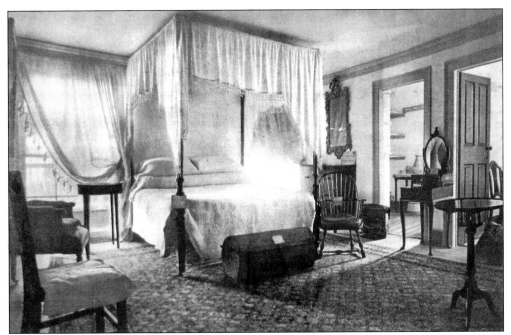

George and Martha's bedroom was directly above the study and was Martha's sanctuary, providing a quiet retreat from family and guests. She planned her schedule, wrote letters, and spent an hour reading the Bible each day. In this bed, on December 14, 1799, Washington died. Upon his death, Martha closed the bedroom for the rest of her life and retired to a room on the third floor. (LCCP.)

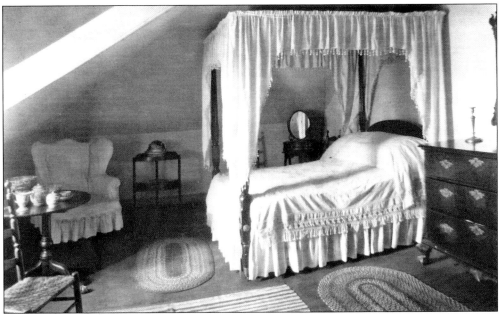

Martha retreated to this small third-floor bedroom, which offered her a degree of privacy, after the death of her husband. This room was part of the 1758 expansion just prior to her marriage to Washington. Her grandson George Washington Parke Custis slept across the hallway. She managed her household and the Mount Vernon estate largely from this room until her death on May 22, 1802. (LCPP.)

Martha's granddaughter Nelly Custis lived in this room from 1759 to 1801. She married Washington's nephew Lawrence Lewis at Mount Vernon on Washington's last birthday in 1799 and lived there until their home at Woodlawn was completed. Their first child was born in this room only a few days before Washington's death. Nelly was confined to her bed and did not attend the funeral services for her step-grandfather. (LCPP.)

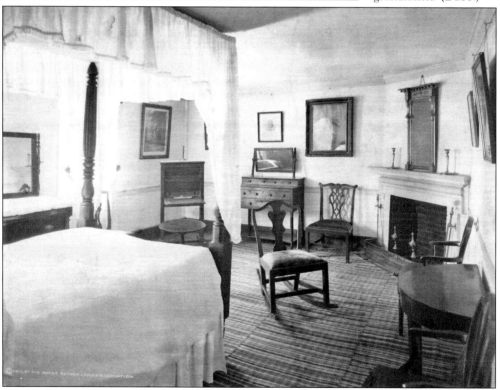

The Washingtons welcomed several hundred guests to Mount Vernon each year, many of whom remained overnight or for several days. Adding to mounting financial strains, Washington could not turn them away without offering food and shelter if needed. As a result, several rooms in the house served as bedrooms. This room is often called Lafayette's Bedroom, where the Marquis de Lafayette stayed while visiting Mount Vernon in 1784. (LCPP.)

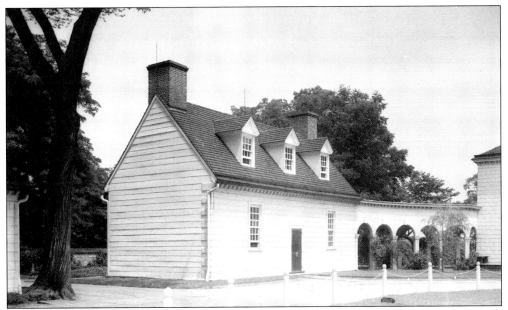

The front of the mansion is framed by two curved walking corridors extending to the servant's hall and the external kitchen. Washington wanted the servant house, shown here, to be used primarily for white servants who might accompany his many guests, as he already had dwellings for his house slaves. The hall was larger than most of the homes of his farming neighbors. (HABS/LCPP.)

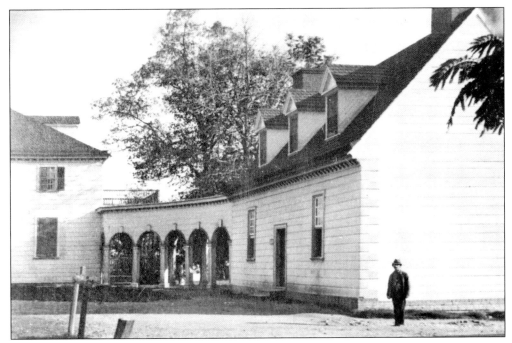

The placement of a large kitchen at the end of the other covered corridor provided symmetry to the courtyard opposite the servant's hall at Mount Vernon. The exteriors of the two buildings were the same size; however, the kitchen area had a much different function than the hall. Enslaved workers stayed above the kitchen, while the servant's hall was reserved for free white servants. (LCPP.)

Normally three meals were served daily at a typical plantation the size of Mount Vernon. Breakfast would be prepared early and served promptly at 7:00 a.m., with dinner at 3:00 p.m. Tea would be served around 6:00 p.m., and if needed, a light meal would be served at 9:00 p.m. The cook Lucy, who provided meals there for years, lived above the kitchen with her butler husband, Frank. (HABS/LCPP.)

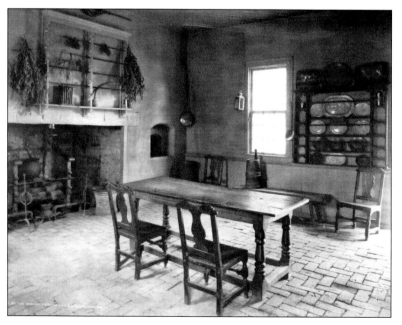

The days were long for the cooks and food preparers, especially with the extra workload for the hundreds of unannounced guests who came to Mount Vernon almost on a daily basis. Assistants for the cook lived nearby in other quarters and would help by hauling water and wood and washing dishes and cooking utensils. (HABS/LCPP.)

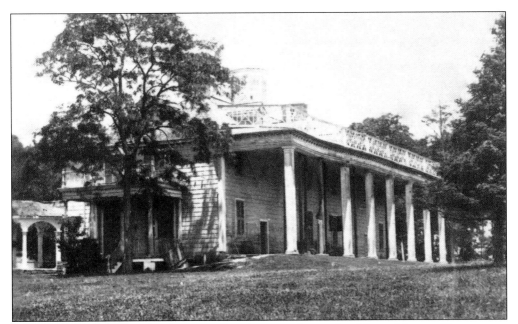

George Washington won the American Revolution and retired to Mount Vernon. He came out of retirement to serve as the first president of the United States for two terms, from 1789 to 1797. He finally was able to rest having helped the fledgling country find good legs on which to stand. The mansion and grounds were purchased by the Mount Vernon Ladies Association in 1859 to preserve this legacy. (LCPP.)

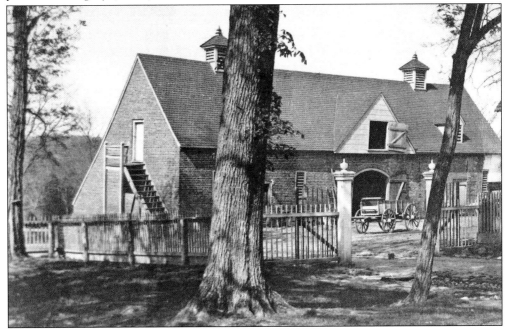

Washington had always wanted to be a great farmer, as is shown in his large brick barn down the hill from Mount Vernon. The land on which Mount Vernon rests was in the Washington family from patent to preservation. A Washington had farmed the land from 1674 to 1859, when the Ladies Association purchased it, a total of 185 years. He did indeed leave a lasting legacy. (LCPP.)

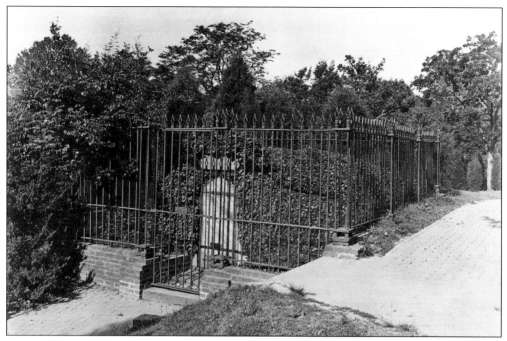

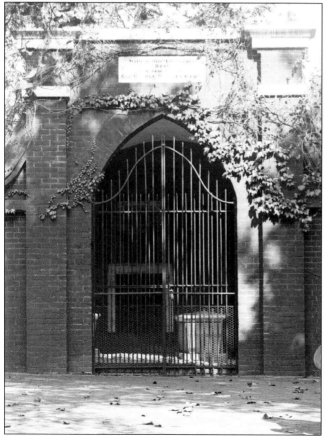

Washington was originally buried in this vault close to the bluff a few hundred feet from the mansion. By his request, he only stayed interred here until a larger, more substantial burial vault could be constructed to his specifications. Martha was also interred in this early vault upon her death in 1802. (LCPP.)

George and Martha's coffins were moved to the new burial vault after several years of being near the bluff and placed in large stone outer coffins. Visitors can see the two resting inside the iron gates. Family members fought Congress to keep his body at Mount Vernon. Congress wanted to bury him in a special vault inside the Capitol, but Washington wanted to be home, at Mount Vernon. (LCPP.)

Two

THOMAS JEFFERSON

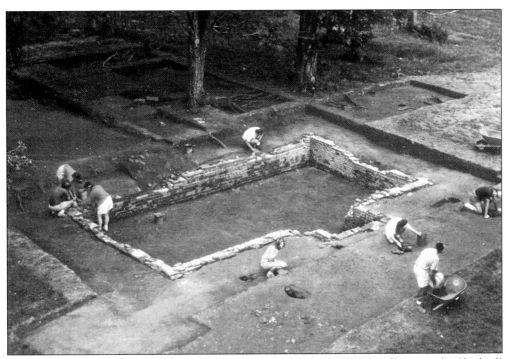

Thomas Jefferson was born on April 13, 1743, to Peter and Jane Randolph Jefferson at the Shadwell Plantation, near the future site of Charlottesville. He was the third of 10 children, with two brothers dying as infants. Peter was a farmer, surveyor, and cartographer who drafting the famous 1751 Fry-Jefferson Map of Virginia. Shadwell burned to the ground in 1770, and archaeologists rediscovered the remains of the foundation in 1991. (TJF.)

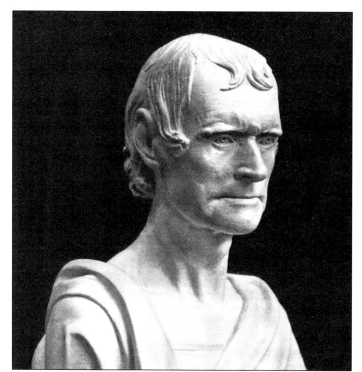

Jefferson spent much of his youth being educated in boarding schools away from home until his father died when he was 14. He attended the College of William and Mary and was inspired by hearing Patrick Henry protest the Stamp Act of 1765. He was then elected to the House of Burgesses. This bust was made from a life mask by John Browere when Jefferson was 81 years old. (LC.)

In 1772, Jefferson married a well-to-do widow from Charles City County, Martha Wayles Skelton. Martha had one child from her first marriage who died just before she married Jefferson. She was Jefferson's strength and partner. Together they had six children, but only Martha (Patsy) and Mary lived to adulthood. Martha became sick and died only four months after her youngest child was born in 1782. (LCPP.)

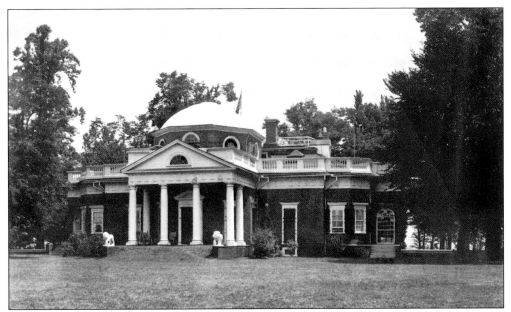

In 1768, when Jefferson was elected to the House of Burgesses, he began clearing the top of the mountain on the Jefferson property above Shadwell in hopes of building what would become Monticello. Construction began on the new neoclassical mansion in 1770, the same year Shadwell burned. Jefferson was 27 and still unmarried, and he had a vision for his home. (LCPP.)

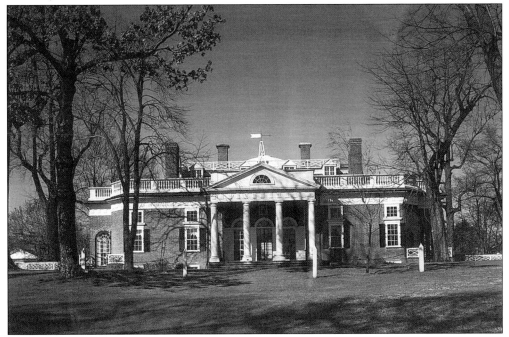

Jefferson married Martha in 1772, and they moved into the south pavilion at Monticello. Later in the year, Patsy was born, bringing much joy to mother Martha after she had lost her first child a few years earlier. They inherited 11,000 acres of land from Martha's father in 1774, including Poplar Forest, and Jefferson retired from practicing law. As his political world grew, so did his vision of Monticello. (HABS/LCPP.)

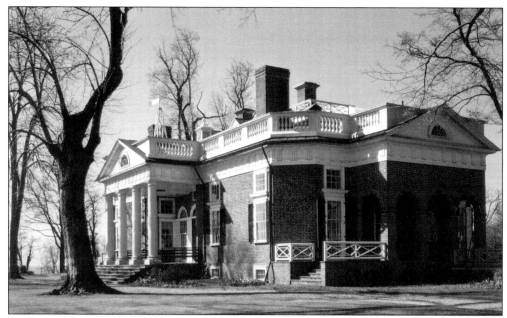

He began writing about rights of the British Americans, understanding the colonists desired certain freedoms from the mother country. He was elected to the Continental Congress in 1775 as the war clouds were gathering. In the spring of 1776, his mother died, and he was elected to the Virginia House of Delegates. Monticello was still in its infancy but was becoming the neoclassical mansion Jefferson would call his "essay in architecture." (HABS/LCPP.)

In the midst of the early months of the American Revolution, Jefferson drafted one of the most famous documents in history in early June 1776. The Declaration of Independence was signed on July 4, the beginning of the end to British rule in the American colonies. During this time, his family lived in the south pavilion, shown here, later connected to the house with a covered terrace. (HABS/LCPP.)

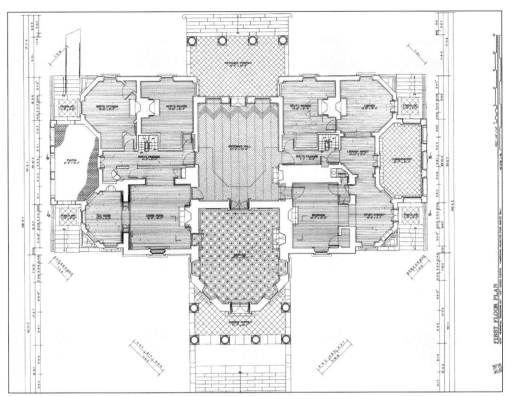

The final floor plans for Monticello reflect the improvements Jefferson made from his original concept. The earlier version placed two porticos on both the front and rear, resembling stacked Greek Parthenons. Deciding to scale down Monticello, he decided on single porticos on either side, but the end product was still a magnificent work of art based on classic Greek and Roman architecture he read about and observed in Europe. (HABS/LCPP.)

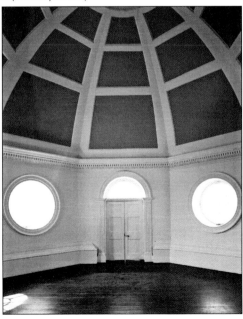

The dome room capping Monticello had several large circular windows around the perimeter with a skylight, but the room's purpose is unknown. Jefferson's grandson Thomas Jefferson Randolph and his wife stayed there in 1815, but the majority of the time the room was used for storage. Another grandchild Virginia Jefferson Randolph, daughter of Martha Jefferson Randolph and Thomas Mann Randolph, thought it was a great place to haunt, calling it her "little cuddy" in 1823. (HABS/LCPP.)

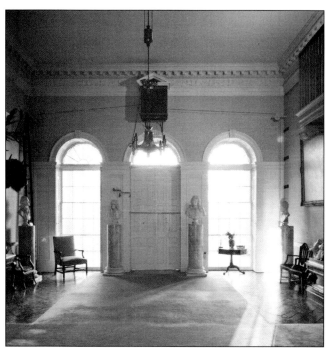

The entrance hall contains a 1792 clock with pulley weights to the right of the entrance. The dark hashes on the right wall mark the days of the week. This portion of the home was used as a reception area and waiting room, with eagles and star patterns decorating the ceiling. Artifacts and mounted animal specimens from Lewis and Clark's western expedition adorn the walls and railings. (HABS/LCPP.)

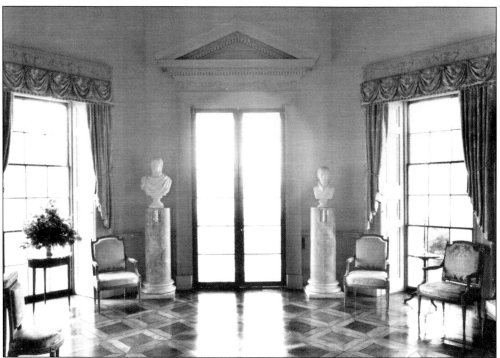

The drawing room, or parlor, had a parquet floor comprised of cherry and beech designed by Jefferson. The room functioned as a center for social activity, with many examples of Jefferson's massive art collection on display and space for music, games, and reading. Weddings, dances, and even christenings were held in the parlor. Automatic double doors were located at the interior entrance to the room. (HABS/LCPP.)

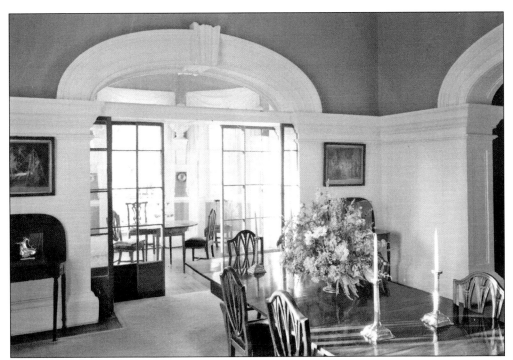

The formal dining room contains one of 13 of Monticello's skylights. Two dumbwaiters by the fireplace brought wine up from the wine cellar. Another of Jefferson's ingenuities was a pivotal serving door that allowed servants to bring dishes to and from the room without disturbing the guests. Daughter Patsy served as both Jefferson's hostess and confidant after Martha died, especially while he was governor and president. (HABS/LCPP.)

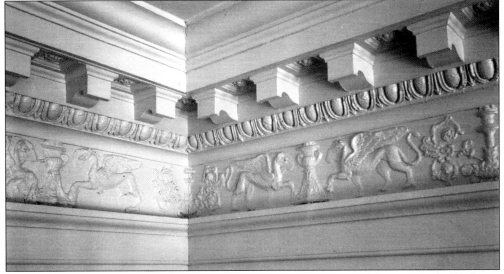

Jefferson spent a large sum on his home, including these lavish cornices of the entrance hall balcony. His political life was rising as he became governor of Virginia from 1779 to 1781 and served as the first secretary of state from 1790 to 1793. He was vice president under John Adams, though they had a previous falling out, and succeeded Adams as president for two terms (1801–1809). (HABS/LCPP.)

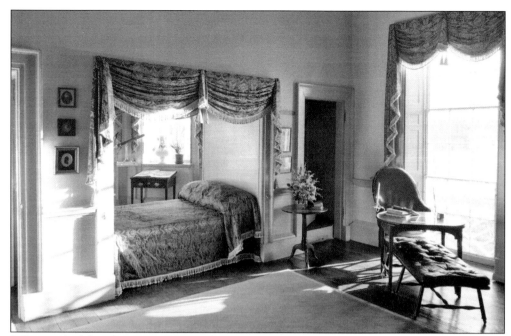

Jefferson's bedchamber was a unique alcove bed open on both sides, with the bedroom on one side and his office on the other. He had one of the earliest examples of indoor toilets, with a privy close to the head of the bed. The room was well lit with a skylight, and the bed, while appearing small because of the alcove, was a double bed 6 feet, 3 inches in length. (HABS/LCPP.)

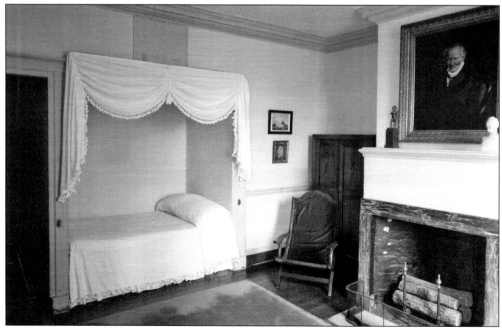

The north "square" room also contained an alcove bed and was frequently used by one of Jefferson's intellectual friends, José Correia da Serra, from Portugal, during Jefferson's retirement years. A closet door can be seen above the bed curtains, accessed by a ladder. The rooms all had 10-foot ceilings for a more spacious experience. (HABS/LCPP.)

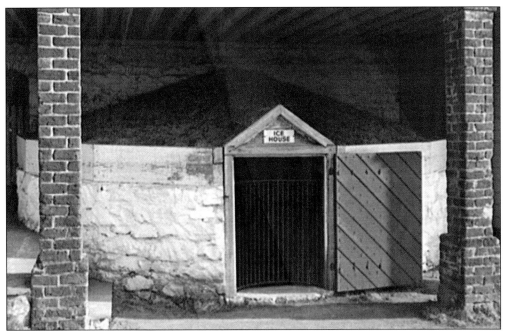

This stone icehouse was located under the covered terraces extending from Monticello. During his presidency, Jefferson more than doubled the size of the United States when the Louisiana Purchase was acquired from France, and his personal quest for knowledge sent the famous Lewis and Clark expedition to the Pacific Ocean. After the burning of Washington during the War of 1812, Jefferson sold his extensive library to Congress. (HABS/LCPP.)

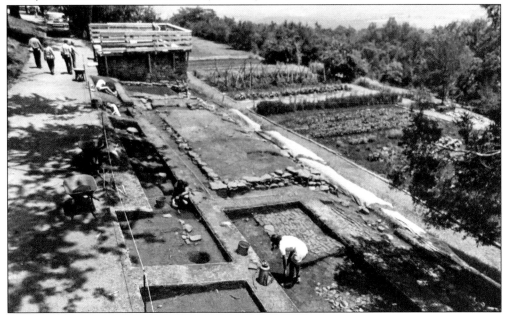

Archaeology at Monticello is ongoing, with research projects including investigations of the Shadwell ruins, garden features, barns, stables, and trash middens. Investigations have also been conducted on the slave quarters, shown here, to give insight to the enslaved people of the plantation and their relationship to the colonial and antebellum household and farm life. (VDHR.)

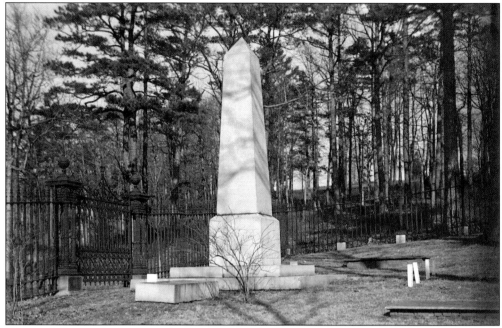

Thomas Jefferson, the third president, died on July 4, 1826, on the 50th anniversary of the signing of the Declaration of Independence he authored. The second president, John Adams, died two hours later, uttering "Thomas Jefferson survives," and the fifth president, James Monroe, died on July 4, 1831. Jefferson was buried in the family cemetery at Monticello next to his beloved Martha. (LCPP.)

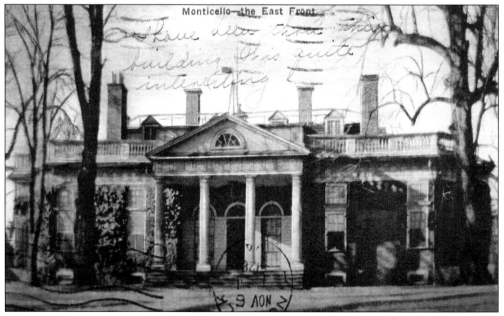

Thousands of tour groups visit Monticello each year to get a glimpse of how the writer of the Declaration of Independence and president of the United States lived. The handwritten note on this Monticello postcard reads, "I have been thru this building. It is quite interesting." One must wonder what type of building would have really been interesting to this visitor if Monticello was only "quite interesting." (VDHR.)

The nickel is the only nationally circulated U.S. coin with the image of a presidential home, illustrating Jefferson's Monticello. First minted in 1938, the Jefferson/Monticello 5¢ piece remains a popular coin. From 2003 to 2005, several new versions of the nickel were issued commemorating the Lewis and Clark expedition and the Louisiana Purchase, both Jefferson's projects. Seen at right is almost the exact image used for the nickel. (USM.)

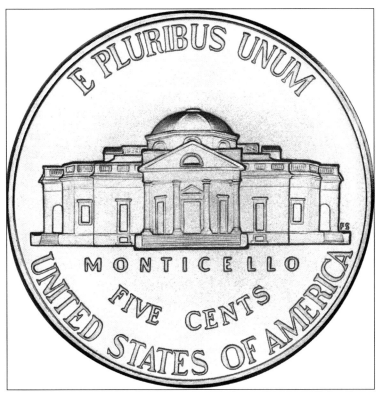

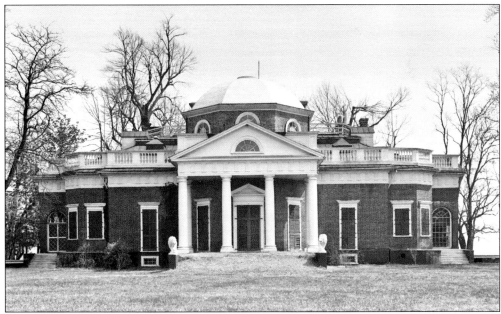

Over $100,000 in debt when he died, Jefferson's heirs sold Monticello and 552 acres in 1831 for $7,000 to James Turner Barclay. Barclay sold it to Jewish American Uriah Phillips Levy three years later, and Levy's preservation efforts preceded Mount Vernon's. Over the next 90 years, the Levys saved Monticello from the ash heap of history, preserving the home and selling it to the Thomas Jefferson Memorial Foundation in 1923. (LCPP.)

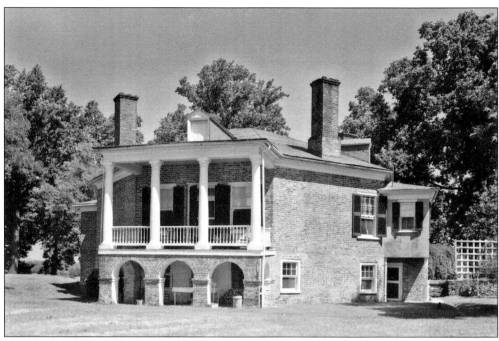

Monticello was a unique architectural statement all by itself, but Jefferson built one other very special home during his lifetime—Poplar Forest, near Lynchburg. He and Martha inherited the 4,800-acre plantation from her father in 1773. Jefferson may have compiled his book *Notes on the State of Virginia* at the manager's house on the property while hiding from the British in 1781. (HABS/LCPP.)

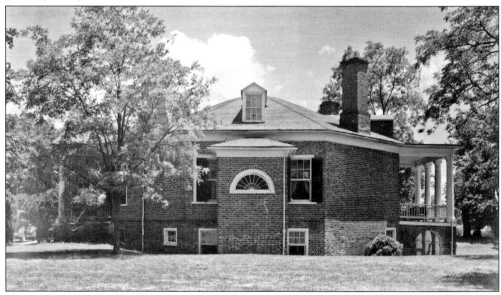

Construction began on his country retreat in 1806, during his second term as president, and he personally supervised the laying of the foundation. Jefferson designed Poplar Forest using many of the same neoclassical elements he had implemented in Monticello and other architectural projects in which he was involved. The structure was so unique to Jefferson's tastes that, as a result, later owners found it difficult to live there. (HABS/LCPP.)

Though he had little time to visit during his presidency, Jefferson visited Poplar Forest at least three to four times a year after leaving office, and he would stay anywhere from two weeks to two months at a time. He referred to it as his summer home, and he often visited during the planting season and harvest. Jefferson also oversaw the planting of his vegetable garden and development of the house and grounds. (HABS/LCPP.)

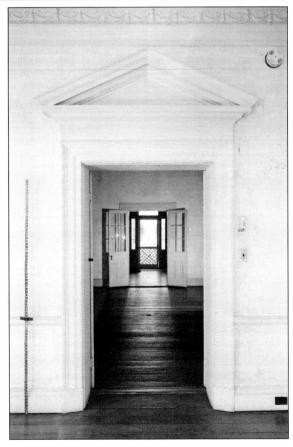

The brick home was a single story over a raised full basement. The view through the central hall at Poplar Forest extended the length of the building from side to side, allowing for unimpeded cross-ventilation during the hot summer months. Even this scaled-back Jefferson home had neoclassical pediments above the doorways with decorative cornices. (HABS/LCPP.)

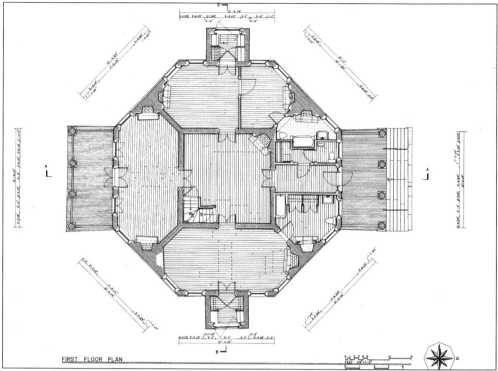

The floor plan of Poplar Forest illustrates the unique architecture Jefferson used in the design of his retreat. The four rooms surrounding the central room form an equilateral octagon, and each of the four rooms are elongated octagons. Single-story porticos are at the front and rear of the structure, and a two-story domed ceiling covers the central space. (HABS/LCPP.)

The elongated octagonal shape of the four exterior rooms allowed for spacious accommodations, regardless of the function performed in the room. Two sets of covered external stairways were added to the home, allowing for access to the lower level without going outside of the house; however, these stairways were intrusive to the occupant of the rooms they entered. (HABS/LCPP.)

A 110-foot-long service wing extended from the house to the kitchen and smokehouse and was rebuilt in the 1990s with painstaking accuracy. Jefferson had installed an indoor privy next to the head of his bed at Monticello. Poplar Forest did not contain such a luxury, but it did have two brick privies placed within a few yards on either side of the home. They were hidden from view by earthen mounds. (HABS/LCPP.)

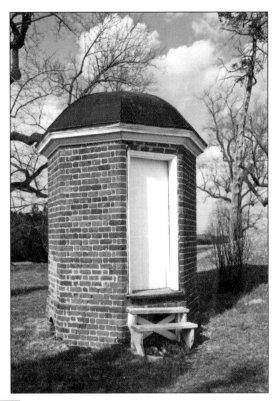

The exterior appearance of the privy suggests a small interior when, in fact, the interior is quite spacious, considering the function. A small seat was even added for children. Jefferson died in 1826, and in 1828, his grandson sold Poplar Forest to neighbor William Cobbs, whose descendants held the property for over 118 years. In 1946, James Watts bought the home, selling it in 1979 to Dr. James Johnson. (HABS/LCPP.)

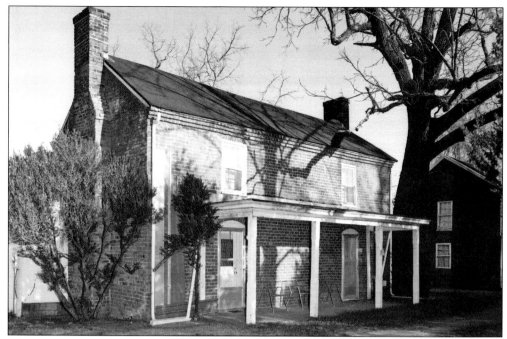

Slave quarters were scattered throughout the landscape of Poplar Forest and were located next to specific activities requiring on-site residency. This slave quarter was probably built after Jefferson died and later became a tenant house. The kitchen fireplace is shown below. Archaeology has found evidence of the cultures of enslaved people on the plantation and continues to shed light on their contributions to the community. (HABS/LCPP.)

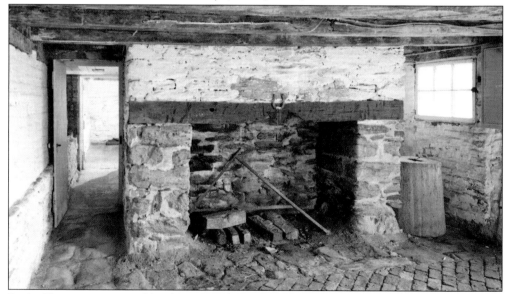

Poplar Forest was acquired by the nonprofit group Corporation for Jefferson's Poplar Forest in 1984; the group received title for 50 acres of the core of Jefferson's plantation. The home has been open to the public since 1986, and the group has been active in restoring it to Jefferson's original fabric and design. Enriching the history of the enslaved community at Poplar Forest is also a top priority, giving the historical site a lasting legacy. (HABS/LCPP.)

Three

JAMES MADISON

James Madison Jr. was born on March 16, 1751, at Belle Grove Plantation, his mother's ancestral home in King George County on the north side of the Rappahannock River. His mother, Eleanor "Nelly" Conway Madison, had gone to her parents' house to have her first child amidst the comfort of her family. The house was gone by the late 1700s, and some accounts claim the location is eroding into the river. (Author.)

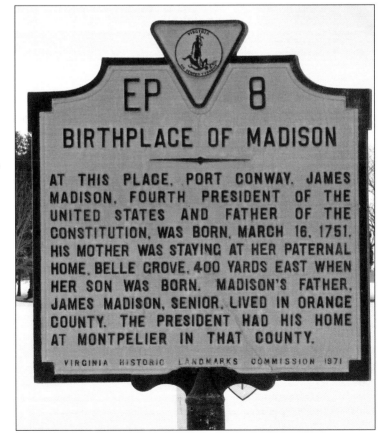

EP 8

BIRTHPLACE OF MADISON

AT THIS PLACE, PORT CONWAY, JAMES MADISON, FOURTH PRESIDENT OF THE UNITED STATES AND FATHER OF THE CONSTITUTION, WAS BORN, MARCH 16, 1751. HIS MOTHER WAS STAYING AT HER PATERNAL HOME, BELLE GROVE, 400 YARDS EAST WHEN HER SON WAS BORN. MADISON'S FATHER, JAMES MADISON, SENIOR, LIVED IN ORANGE COUNTY. THE PRESIDENT HAD HIS HOME AT MONTPELIER IN THAT COUNTY.

VIRGINIA HISTORIC LANDMARKS COMMISSION 1971

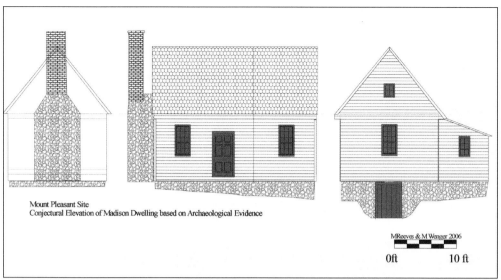

Mount Pleasant Site
Conjectural Elevation of Madison Dwelling based on Archaeological Evidence

MReeves & M Wenger 2006

0ft 10 ft

Nelly and James Madison Sr. were married in 1749 and lived at Mount Pleasant in Orange County, where his father, Ambrose Madison, received a land patent in 1723. Madison Sr. was a vestryman, sheriff, surveyor, justice, and colonel in the militia. James Madison Jr., or "Jemmy" as he was often called, with a strong Southern accent, was the eldest of the 10 Madison children, three of whom died before the age of seven. (MFMRMW.)

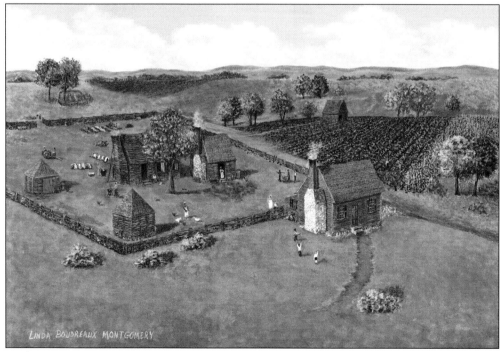

LINDA BOUDREAUX MONTGOMERY

Madison Sr. was not only a very prosperous plantation owner, he also owned several other industries, including a distillery, ironworks, plantation store, and construction business. Most of the children were born at the Mount Pleasant plantation, shown here on the right in an artist's rendering. A detached kitchen was located adjacent to the home, with slave quarters and other outbuildings enclosed within a fenced area. (MFLBM.)

Mount Pleasant was about a half mile from where Montpelier would be built. Burned around 1770, the house was razed, possibly to clear the area around the complex for cultivation since the new brick mansion was built by that time. Archaeologists found the remains of Mount Pleasant, a simple two-room residence with a stone chimney, in a field next to the family cemetery, providing the earliest Madison family artifacts. (MF.)

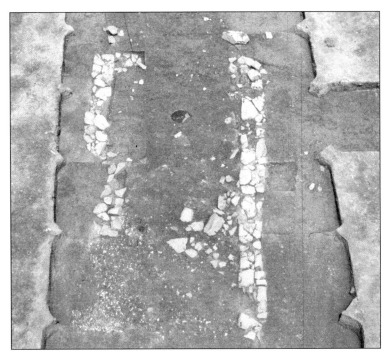

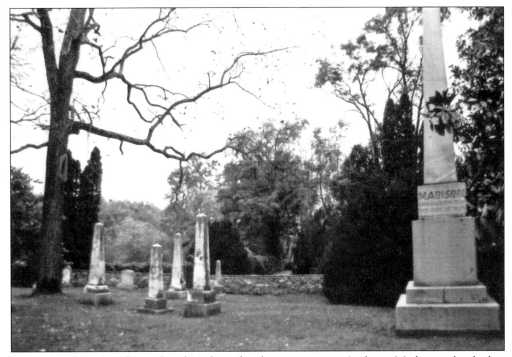

The earliest burial in the enclosed Madison family cemetery was Ambrose Madison, who died in 1732. The burial ground is located only a few hundred feet from site of Mount Pleasant and is a rare example of a president of the United States' grave site being located in the same cemetery as his parents and grandparents. Madison Sr. died in 1801 and Nelly in 1829 at age 97. (VDHR.)

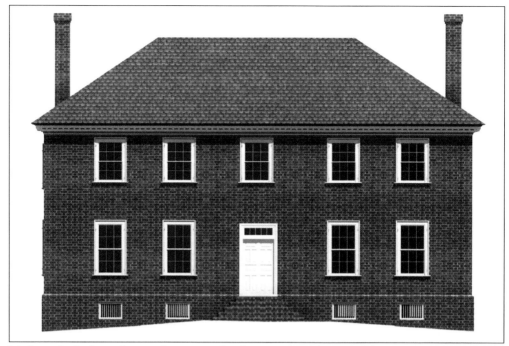

Madison Sr. built a substantial two-story brick mansion with a raised basement around 1763. A symbol of his financial prosperity, it was the largest brick structure in Orange County. The home, called Montpelier, consisted of four rooms on the main floor and five upstairs, with a detached kitchen. The dining room and parlor were in the front of the main level, with the remainder of the house considered private areas. (MFPI.)

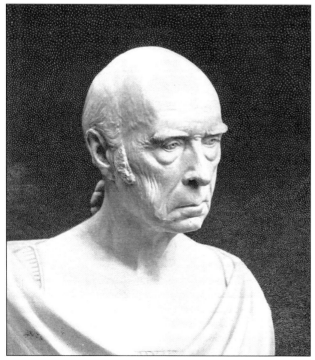

The earliest memories of Madison Jr. were of him helping to move furniture from Mount Pleasant to the new home. He studied Greek and Latin early in life and attended the College of New Jersey (now Princeton University). Serving in the Continental Congress, Madison read hundreds of books, studying failed self-ruled governments to find out why they collapsed, and his Virginia Plan was adopted as the base for the Constitution. (LC.)

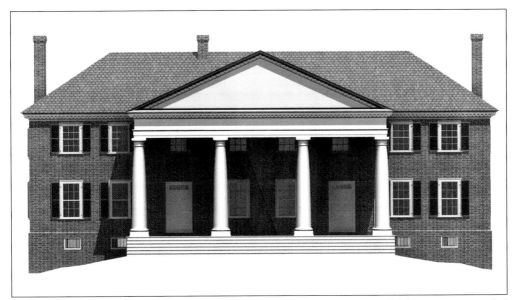

Madison enlarged his father's mansion after his 1794 marriage to Dolley. The home was extended to 86 feet in length, adding two more rooms on each floor and a second main entrance, resembling a grandiose duplex. A two-story Tuscan-style portico encompassed both the old and new front entrances. Madison Sr. and Nelly lived in the south (right) end, and Madison Jr. and Dolley lived on the north (left) end. (MFPI.)

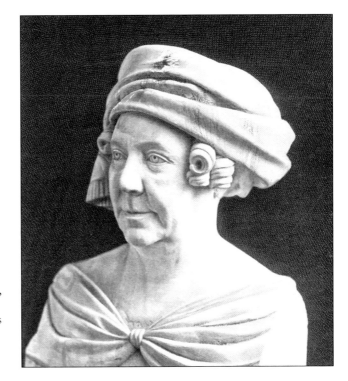

Dolley Payne was born in 1768 at the New Garden Quaker settlement in North Carolina. In 1783, her parents sold their plantation, freed their slaves, and moved to Philadelphia. In 1790, she married John Todd, a lawyer, and they had two sons. In 1793, yellow fever took her husband and youngest son. Madison was introduced to Dolley, and the widowed mother of one son married him in 1794. (LC.)

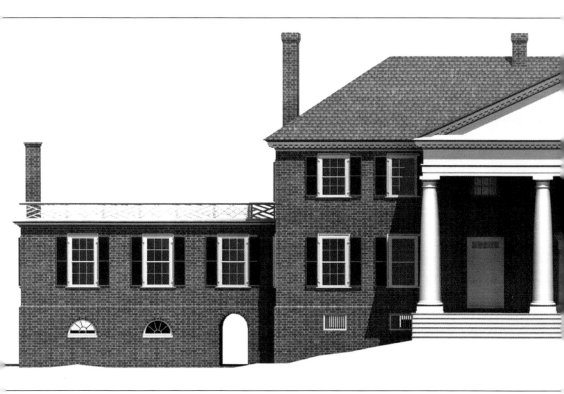

The mansion, already the largest in the county, was enlarged yet again during Madison's first term as president from 1809 to 1813. He erased the duplex design by closing two sets of the front windows, enlarging the others, and adding a central door. He removed inner walls separating the two halves of the duplex and added two one-story wings with full cellars. The north wing was intended as a library, with the main cellar kitchen for James and Dolley's family. The south wing

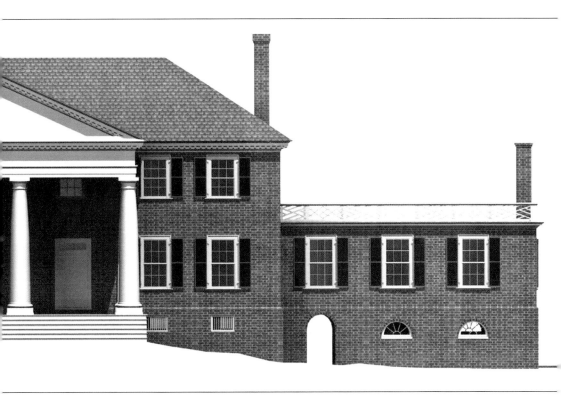

was an addition for his widowed mother, Nelly, and contained her own cellar kitchen. Prior to these additions, the kitchens had always been detached buildings. The wings were topped with wood-floored terraces, enlarging the second-story living spaces while covering an ingenious water collection system under the terrace flooring to provide drinking water for the house. (MFPI.)

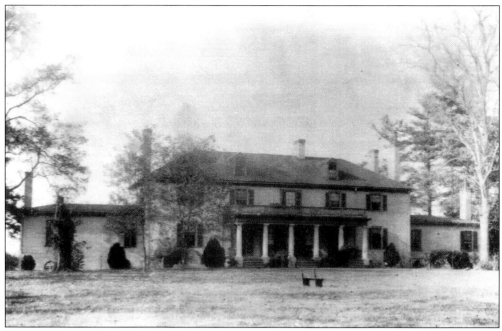

The rear, or east, side of Montpelier was open to a grassy expanse of a relatively level to gently sloping lawn. A one-story colonnade with a second-story terrace was added to the mansion when the wings were constructed in the 1809–1813 period. Madison had now built a home he considered worthy of a president of the United States, which would never quite be equaled again. (VDHR.)

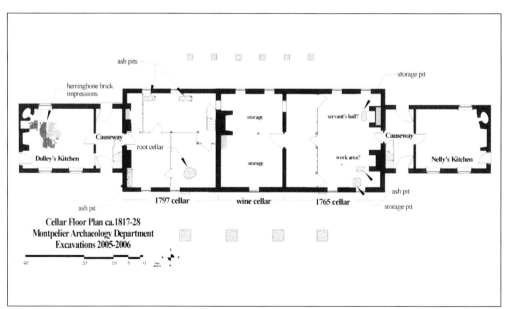

This cellar-level plan illustrates the labyrinth of walls and doorways between the large rooms from the three construction phases of the mansion. The two kitchens flank the main block, with causeways separating them from the central part of the home. The Madisons did not lack storage areas or locations for a cooled wine cellar within the thick, hand-molded brick walls in the lower recesses of their home. (MF.)

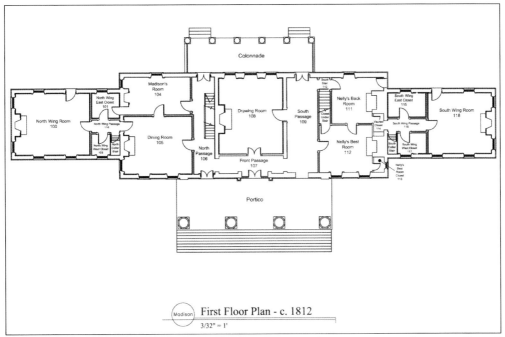

First Floor Plan - c. 1812
3/32" = 1'

When Madison removed the central wall dividing the two earlier construction phases, two "outer" walls created a large central drawing room, or reception area, with magnificent paintings hung on the walls. His mother, Nelly, lived in the earliest section of the house she had built with her husband. The main dining room was on the opposite side of Nelly's area and adjacent to the room where President Madison died. (MF.)

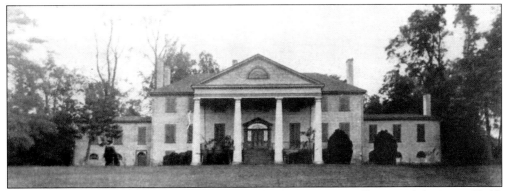

James and Dolley slept in the large bedroom over the dining room. Dolley's son, John Payne Todd, and guests slept in the other bedrooms. The old library section was where James Madison came to read and study while working on the Constitution and Bill of Rights and where he posed many a political question to visitors such as Thomas Jefferson. From the library, Madison could view both visitors and the mountains. (MF.)

The dynamic Dolley Madison supported her husband in his political endeavors and served as first lady for four terms: Two terms were for widower and friend Thomas Jefferson (1801–1809), with his daughter Patsy, and two were for her husband (1809–1817). She stayed at the White House when the British advanced in 1814, when she famously directed the removal of Stuart's painting of Washington just before the building was burned. (LCPP.)

She was brassy, classy, and flashy, and the nation adored her. After Madison died in 1836, Dolley returned to Washington, where she became a widowed socialite. She was the life of many parties and galas, hostess to foreign dignitaries, and confidant to her succeeding first ladies. She died in 1849 but was not buried beside her husband until 1858. Here a female admirer views Dolley's stone at Montpelier. (VDHR.)

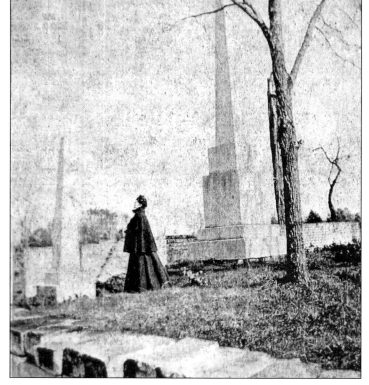

Dolley had to sell their beloved Montpelier by 1844 because of insurmountable debts. Between 1844 and 1901, seven owners bought Montpelier, most notably Thomas and Frank Carson (1857–1881) and partners Louis Detrick and William Bradley (1881–1900). The large estate and mansion were hard to maintain and were in a deteriorating state. The view from the portico was magnificent but could not fetch a high price. (MFKW.)

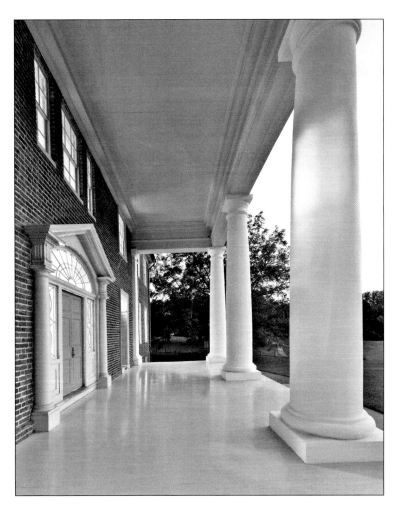

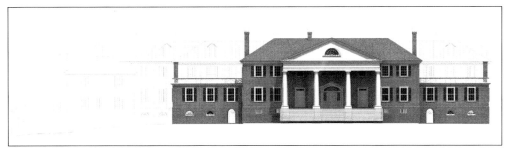

Detrick and Bradley did extensive remodeling to the dilapidated mansion, to the point that James and Dolley would have recognized little of the interior. William duPont bought the estate in 1901 and further changed the 22-room mansion into a massive 55-room "palace" with 12 bathrooms. The exterior was stuccoed and painted to cover the brickwork to the point where few recognized the real Montpelier built by the Madisons. (MFPI.)

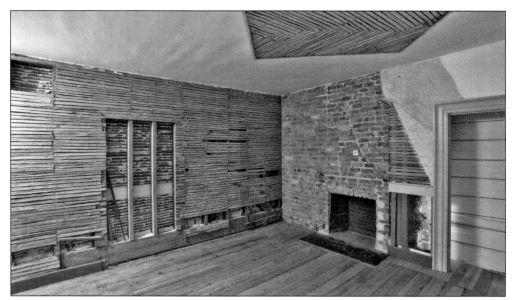

The property was transferred from the duPonts to the National Trust for Historic Preservation in 1984. In 2000, the Montpelier Foundation became the steward of the mansion and grounds. Unprecedented restoration efforts took five years to return much of Montpelier to the Madison era. One of the upper rooms has remained the Restoration Room, dedicated to illustrating the renovation process by leaving bare walls and ceilings for visitors to view. (MFKW.)

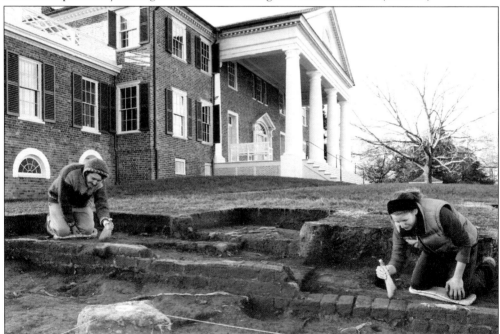

Full-time archaeology staffs with dedicated volunteers have excavated substantial areas inside the cellar level as well as much of the grounds around the mansion and outbuildings to more fully comprehend the historic activities that occurred at Montpelier. Research continues on slave quarters, landscaping questions, and analyzing the thousands of recovered artifacts to identify other outbuildings and features. Here archaeologists excavate in front of the north kitchen. (MF.)

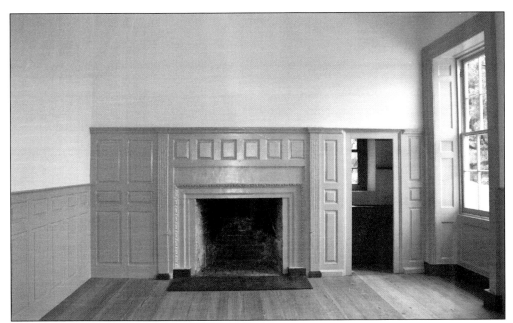

Madison's mother, Nelly Conway Madison, built the first portion of Montpelier with her husband, Madison Sr. When the mansion was expanded, she and her husband kept their portion of the house. Here Nelly's Best Room (main room) has been restored and is awaiting the return of period furniture. She lived to a ripe old age of 97, surviving her son's presidency, the first presidential mother to do so. (MF.)

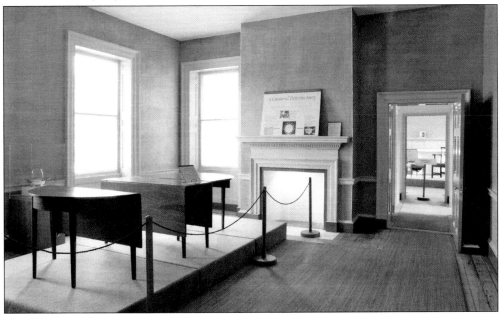

The dining room was built during the second phase of construction. Madison did not install the elaborate decorative woodwork that Jefferson did at Monticello and Poplar Forest; however, the spacious rooms gave Montpelier class above other period mansions. In his last years, a crippled Madison stayed in the rear room off the dining area, talking with visitors during dinner. He died in that room on June 8, 1836. (MF.)

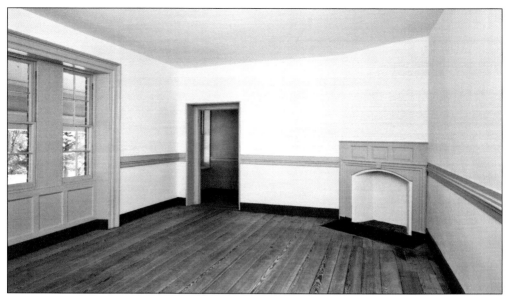

Madison's personal library, perhaps second only to Thomas Jefferson's in the importance for the future of the United States, was upstairs adjacent to the portico. This room was Madison's retreat for studying ideas and concepts from failed self-governed nations, which contributed greatly to the shaping of the Constitution and Bill of Rights for the new U.S. government, still in existence after 200 years. (MF.)

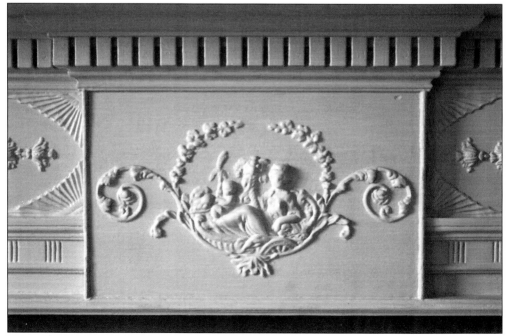

Montpelier was more spacious than Monticello but lacked the decorative trim and woodwork Jefferson included in his home. This mantel in the Madison bedroom illustrates at least one decorative element in the house. Fortuna, the Greek goddess of fortune and fertility, is riding in a chariot with a young male child (putto) while holding a cornucopia, perhaps trying to bring financial and family blessings to the house. (MF.)

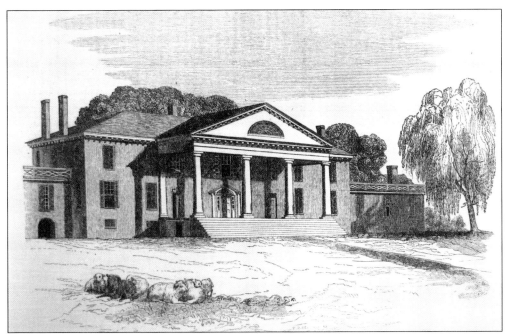

Montpelier was one of the finest examples of Federal-period architecture in the country and remains one of if not the largest home built by any president of the United States. The first portion was constructed in 1763, before the Declaration of Independence was signed, and the last portion was finished just prior to the War of 1812. This engraving captures the mansion's pre–Civil War elegance. (LC.)

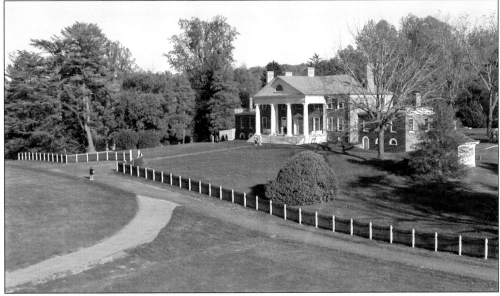

The renovations to Montpelier in the early 21st century have once again brought the original elegance to the mansion and grounds. Restoration of the entrance paths and fences, and other facets of the historic landscape, will only serve to enhance the experience planned by the Madisons. Research into slave life and the day-to-day aspects of a colonial plantation will also help to accurately preserve the past. (MF.)

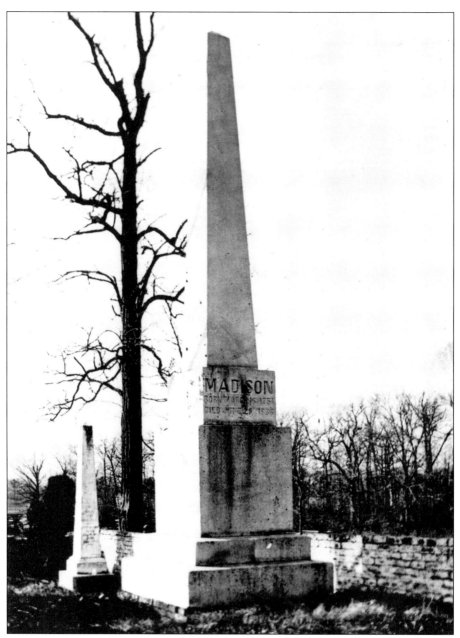

James Madison, the fourth president of the United States, has been called the "Father of the Constitution," a title bestowed on him because of his concepts of developing a long-lasting and permanent government ruled by the people, not a nobility or dictatorship. The land containing Montpelier was the only home Madison really remembered, having moved from Mount Pleasant into the new house when he was 12 years old. The early education he received provided him with a lifelong ambition of making life better for not only him and his family but also for his fellow Virginians and all citizens of the fledgling United States of America. He helped shape world politics when he aided in the development of the Constitution and the Bill of Rights. He asked for declaration of war against Great Britain in 1812 and signed the treaty to end it, making the country stronger and recognized by the world as a strong, self-governed country. (LCPP.)

Four

JAMES MONROE

James Monroe was born to Spence and Elizabeth Jones Monroe on April 28, 1758, at his father's homestead in Westmoreland County. This sketch of the Spence Monroe home, completed in 1845, is the earliest realistic drawing of the birthplace of a Virginia-born president, as no such accurate drawing exists for George Washington, Thomas Jefferson, or James Madison's birthplaces. James's great-grandfather Andrew Monroe came from Scotland and patented the adjacent tract in 1652. (VDHR.)

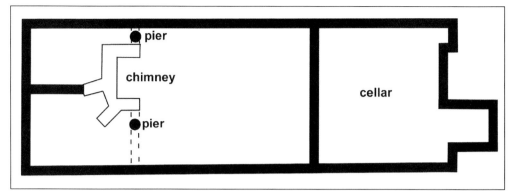

The early Monroe farm was surrounded by Monroe's Creek, several miles from the Potomac River and a few miles from George Washington's birthplace. Monroe was one of five children, and his father was both a carpenter and a farmer. His mother was a good housewife who died when he was in his teens. His birthplace homesite was marked by a large tree for years and was rediscovered during archaeological investigations in 1976. (Author.)

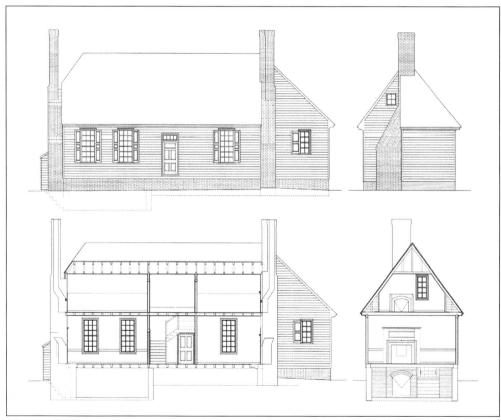

The wood-frame home was a 1.5-story building with a stone-lined half cellar. The Monroes sold the property in 1783. Westmoreland County owns the property, and the James Monroe Memorial Foundation has a long-term lease with the county and has already built a visitors center. The foundation intends to reconstruct the birthplace based on the College of William and Mary archaeological findings and the 1845 drawing. (JMMF.)

Young Monroe attended Campbelltown Academy briefly and then went to the College of William and Mary. His education was cut short by the American Revolution. Monroe fought in the war and was wounded in the shoulder at Trenton. He entered politics, was elected to the Virginia House of Delegates in 1782, and served in the Continental Congress from 1783 to 1786. This painting by Samuel Morse was much liked by Monroe's daughter. (LCPP.)

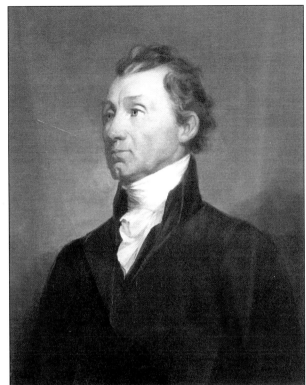

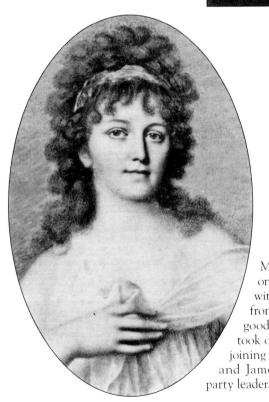

Monroe married 17-year-old Elizabeth Kortright on February 16, 1786. She was a beautiful woman with a sense of fashion from New York. Moving from New York to Fredericksburg, she became a good Virginian as her husband's political career took off. In 1790, Monroe was elected U.S. senator, joining the Republican faction led by Thomas Jefferson and James Madison. By 1791, he was the Senate party leader. (LCPP.)

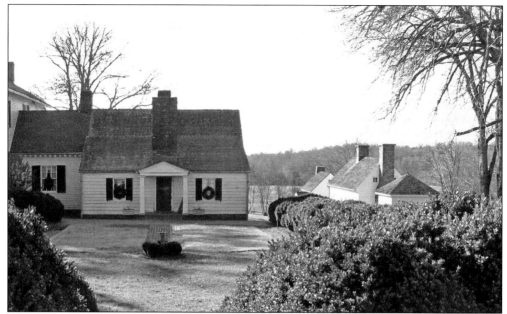

In 1793, Monroe purchased 1,000 acres in Albemarle County that he called Highlands, expanding the plantation later to 3,500 acres. The tract was within view of Thomas Jefferson's Monticello; Jefferson shared Monroe's vision of developing a social community with James Madison and other Virginia intellectual elites. The Monroes claimed Highlands as their home for many years, although James's political career kept him away much of that time. (Author.)

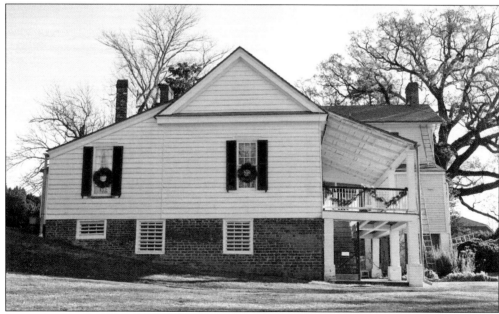

Soon after purchasing Highlands, Monroe built a small two-story, wood-frame dwelling, which he then expanded. Jefferson was delighted that his good friend was on the adjacent property. Monroe resigned his Senate seat after being appointed Minister to France in 1794 by President Washington. As ambassador, he was able to secure the release of Thomas Paine when the latter was arrested for his opposition to the execution of Louis XVI. (Author.)

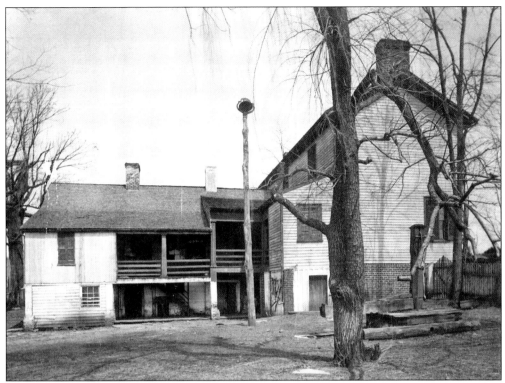

The house was relatively plain, intended only as an interim house until Monroe was financially able to construct a larger, more elegant home, which would not happen at this location. The name Ashlawn was given to the property in the late 1830s by owner Alexander Garrett, and the addition (more like a separate house, seen here on the right), was built after the Civil War by owner John Massey. (LVA.)

Highlands was situated on the side of Carter's Mountain, with the house on the top of a small foothill nestled in the valley, hence the name. Jefferson designed the house for Monroe so his family could find solitude away from the political world outside. Monroe was never able to build a larger home there. (Author.)

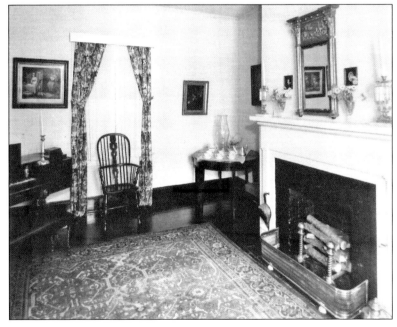

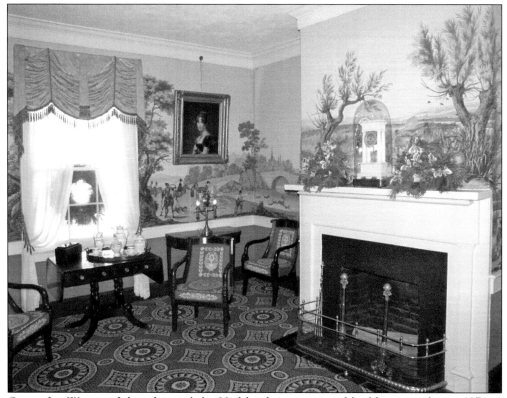

Owner Jay Winston Johns donated the Highlands property and building complex in 1974 to the College of William and Mary, which has since overseen the renovation of the house and outbuildings. The wall coverings have been designed to present a Monroe-era ambience to the house, and the vast majority of the furnishings were once owned by the Monroe family. Great care has gone into proving authenticity of the Monroe artifacts. (Author.)

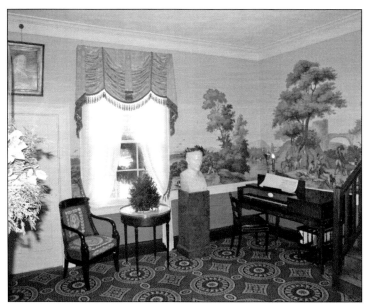

The house serves as a museum to the James Monroe family, displaying items from their personal and public lives from Virginia, Washington, and abroad, such as this marble bust of Napoleon. Monroe served twice as the French ambassador as well as ambassador to Spain and Great Britain, giving the couple exposure to European culture and values. During his tenure in France, he negotiated the Louisiana Purchase for Jefferson. (Author.)

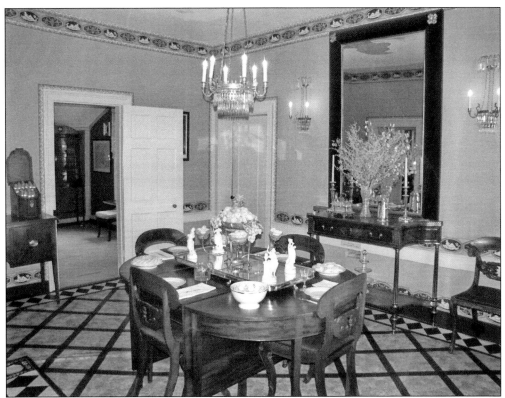

While in France, Elizabeth visited Adrienne Lafayette, wife of the famous French general who aided in the American Revolution, while she was in prison, helping to win the marquise's release in a widely publicized event. Daughter Eliza Monroe attended an exclusive boarding school for girls. Upon their return from France, the Monroes shipped most of their French purchases to their home, and many of the purchases adorn Highlands today. (Author.)

When the Monroe family was away from Highlands during his many political assignments, other family members lived at the plantation. Monroe's uncle, Joseph Jones, farmed the place in his absence, and Monroe's daughter Eliza lived there for a few years when she was first married. The original portion of the house may have had only two rooms with a basement, enlarged later by Monroe as the family grew. (Author.)

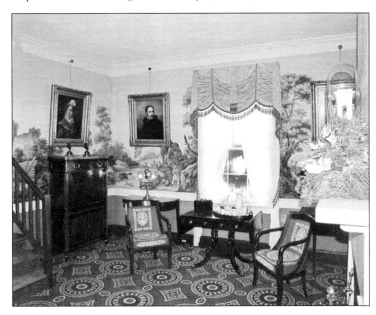

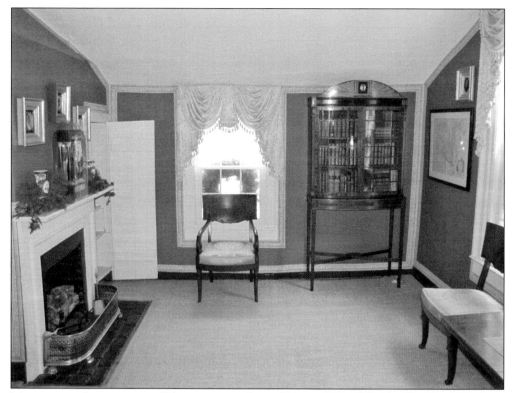

Monroe served as governor of Virginia twice: from 1799 to 1802 and for the first four months of 1811. As governor in 1800, he stopped Gabriel's Insurrection, a plot by a slave named Gabriel to capture Monroe and others and hold them hostage until they had a boat and could sail to freedom. Monroe was pleased when his friend Thomas Jefferson became president in 1801. (Author.)

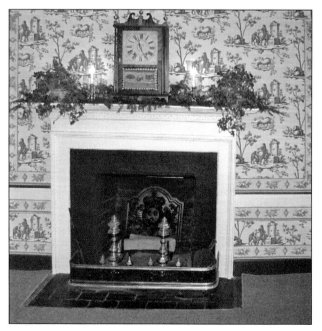

After leaving the governor's seat, Monroe became an ambassador to Great Britain, then Spain. After a failed bid for the presidency in 1808, he retired from public service for three years. He returned as a congressman in 1810 and was soon elected governor again in 1811 before President Madison asked him to be the secretary of state. (Author.)

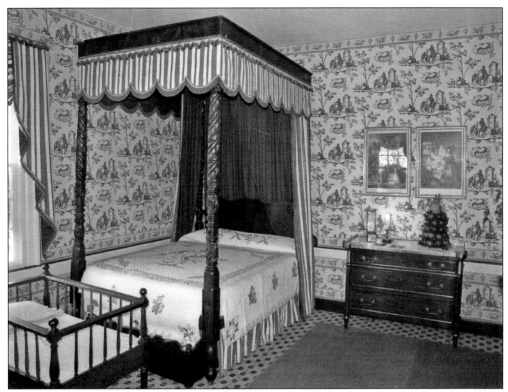

When Monroe served in Richmond and Washington, Elizabeth commuted between both the Virginia and national capitals, and combined with other personal problems, she developed serious health issues, which led to her increasing withdrawal from public life. Many of her symptoms suggest epilepsy or some illness that in later years frequently left her shaking and falling into unconsciousness. This Monroe bed is in the master bedroom at Highlands. (Author.)

This room is presented as the nursery at Highlands. James and Elizabeth had three children, Eliza Kortright, James Spence, and Maria Hester Monroe. James Spence lived less than a year, dying in 1800, which contributed to Elizabeth's health issues. The 1802 birth of Maria in Paris gave new life to the family. Eliza developed a long friendship with Hortense Beauharnais, daughter of Josephine Bonaparte. (Author.)

The main chimney in the home had a divided base, providing heat through separate fireplaces for the two side rooms as well as allowing for an entrance through the main front door. The majority of people passing through the arched passage, designed by Thomas Jefferson, had to bend down because of the low ceiling of this rare architectural feature. (Author.)

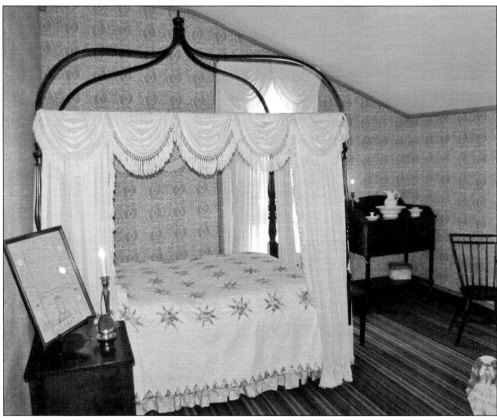

As secretary of state, Monroe tried diplomacy with Great Britain to avoid war to no avail. After war was declared in 1812, Monroe became involved with the war effort to ensure a successful conclusion for the nation. In the days following the burning of Washington in 1814, Monroe also became the acting secretary of war, helping to plan the victories at Fort McHenry and New Orleans. His daughter's bedroom is shown here. (Author.)

These outbuildings were original to the Monroe era. The central building was a slave quarter, later converted to lodging. The smokehouse on the right and a lodge for guests on the left have been renovated. Monroe was never home long enough to take formal charge of the farming operations, relying mostly on hired managers. Fifteen slaves farmed several crops, including corn, tobacco, and wheat, and raised sheep. (Author.)

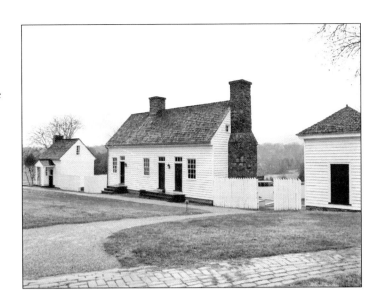

Monroe's political success peaked when he became president in 1816, defeating Rufus King. His first term introduced the Monroe Doctrine, and he was so successful that he ran basically unopposed in 1820, the only election without opposition aside from George Washington's two bids. Mounting debts made him sell Highlands in 1825 after he left office, and his desire to run a classic Virginia farm ended. (Author.)

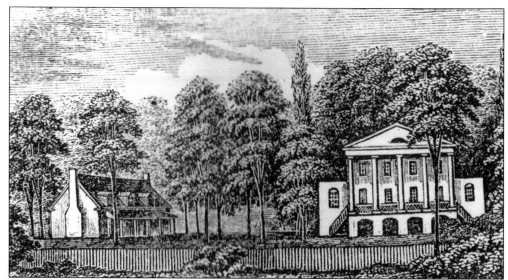

Monroe purchased 4,400 acres in Loudoun County in 1794, a year after purchasing Highlands. The property was located closer to the new national capital being developed in the District of Columbia. The Monroes periodically stayed in the six-room manager's house, shown to the left, while planning the larger house called Oak Hill. The smaller building was also used from 1808 to 1817 by Monroe's brother Andrew, his plantation manager. (LC.)

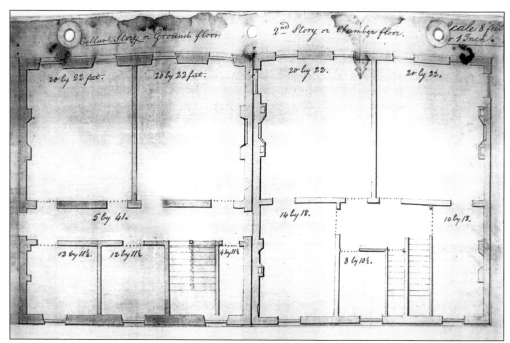

Oak Hill was Monroe's Washington retreat. In 1822, the Monroes began construction of a brick house and large Tuscan portico, using suggestions from Thomas Jefferson and others. Monroe wrote, "A plan of a house which Col. Bomford has drawn for us and of which we very much approve. It is a square building, with two wings, which latter, being one story only will take much fewer bricks than one entire building." (VDHR.)

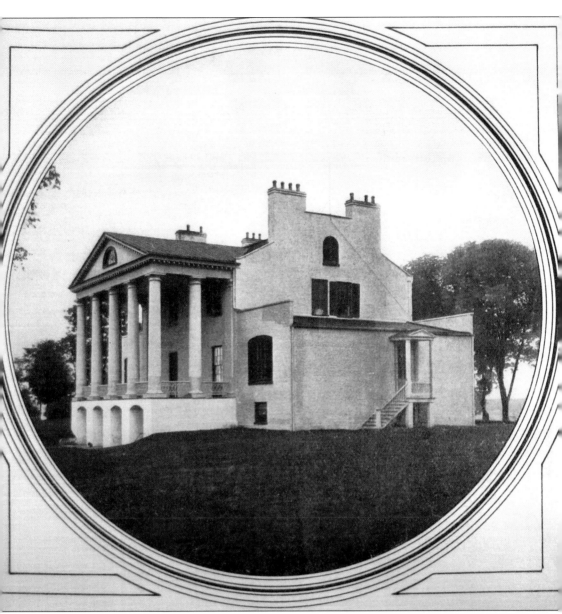

Monroe's presidency resolved decades-old grievances with the British and acquired Florida from the Spanish. Monroe's administration was hampered by the economic depression brought on by the Panic of 1819 and by the debates over the Missouri Compromise that same year. His support for the American Colonization Society, establishing the nation of Liberia for freed blacks, led to the Liberian capital's name, Monrovia. The 1819 depression did not help Monroe's own financial assets, especially as he was putting a large sum of money into Oak Hill. Monroe was not a loner at Oak Hill. John Quincy Adams and General Lafayette visited in 1825. Lafayette was visiting his old friends from the American Revolution and thanking Elizabeth again for winning his wife's release from prison. Oak Hill was finally the mansion Monroe had longed for, and the home with which he is most associated, as he stayed less and less at Highlands. During retirement after the presidency, Monroe did not remain inactive. He served as chairman of the Virginia Constitutional Convention for revising the state constitution and in several other advisory roles. (VDHR.)

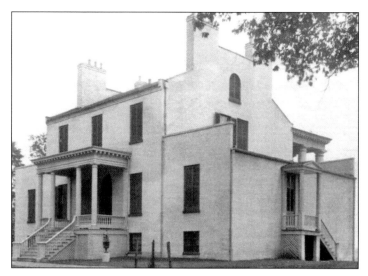

When Monroe's second term was over in 1824, Elizabeth was in such poor health they remained in the White House for three weeks. Retiring to Oak Hill, her activities remained focused on family, and she assumed no public role or public activities. Working on Oak Hill may have helped. The paving stones in the kitchen floor may have been in the White House prior to the burning in 1814. (VDHR.)

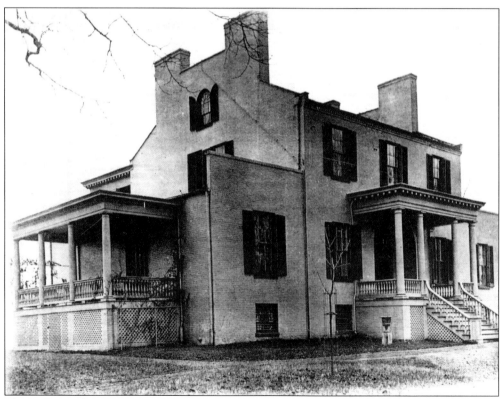

The 2.5-story house was square in plan on a raised basement with two flanking one-story wings. The main section had three bays on the north side and four on the south, the same side containing the large portico. The first floor contained two drawing rooms, a library, three bedrooms, an office, and two large formal rooms that opened to the portico. The second floor had four bedrooms. (LVA.)

The rear entrance to the main block of the mansion has an arched glass window above the recessed doorway, opening to the formal gardens. Today Oak Hill is privately owned and listed as a National Historic Landmark for its architectural significance and relationship to Monroe. Monroe was at Oak Hill when he developed his policies leading to the infamous Monroe Doctrine. (LVA.)

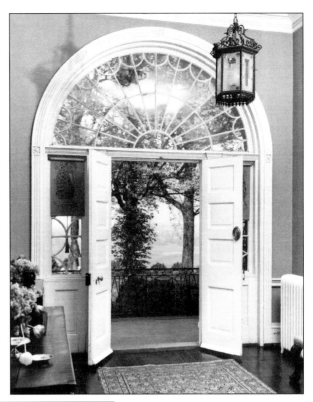

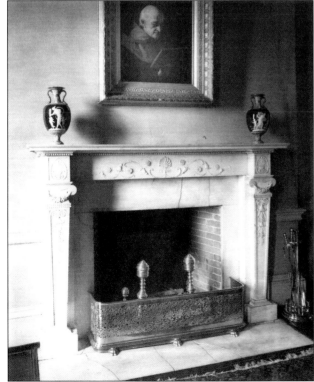

The marble mantels in the drawing room and dining room at Oak Hill were ordered for Monroe by Lafayette and shipped from Italy. In 1826, Elizabeth suffered a severe seizure and collapsed near an open fireplace, sustaining severe burns on her body. While the accident was not fatal, her already frail condition was not enhanced by the ordeal, and she lived only three years after the accident. (LVA.)

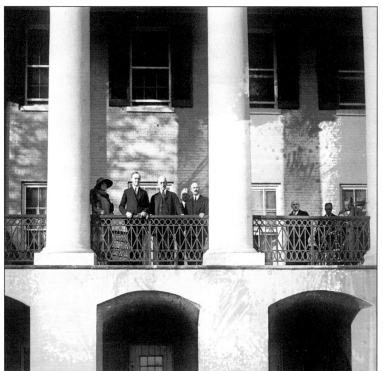

James and Elizabeth needed money, especially after he left office. They tried to sell Highlands and Oak Hill, but the economic crisis would not support such a transaction. He owed over $75,000 by 1825 and was finally able to sell Highlands the next year. Monroe wrote often in these last years, even a book on the origins of free governments. There were 44 slaves and servants at Oak Hill in 1823. (LCPP.)

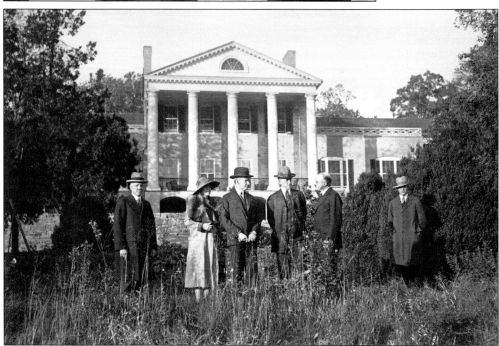

Elizabeth died at Oak Hill on September 23, 1830, and was buried in a vault near the house, where the formal gardens are today. She was at last in peace. Monroe, still trying to sell Oak Hill, moved to New York soon after to live with his daughter Maria. In this view, Pres. Calvin Coolidge, third from left, visits Oak Hill. (LCPP.)

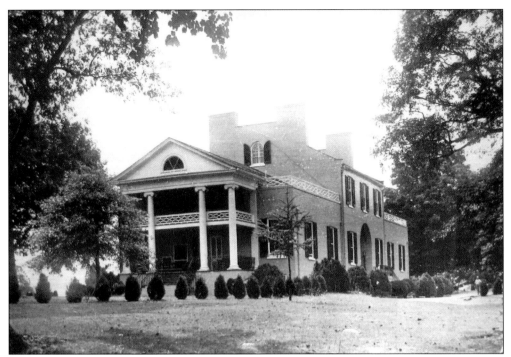

Monroe wrote to James Madison in 1831, stating, "It is very distressing to me to sell my property in Loudoun, for besides parting with all I have in the State, I indulged a hope, if I could retain it, that I might be able occasionally to visit it, and meet my friends, or many of them, there." Side porticos were added to Oak Hill in 1922. (VDHR.)

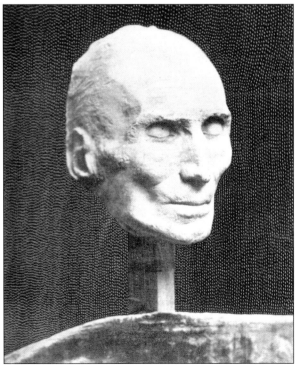

Monroe's health deteriorated, and he died in New York City on July 4, 1831, the 55th anniversary of the signing of the Declaration of Independence. He was buried in New York. His friend Thomas Jefferson died on the 50th anniversary. Monroe's death mask by John Browere does no justice to the face of the man, but it is included here as the only real image of Monroe aside from paintings and sketches. (LC.)

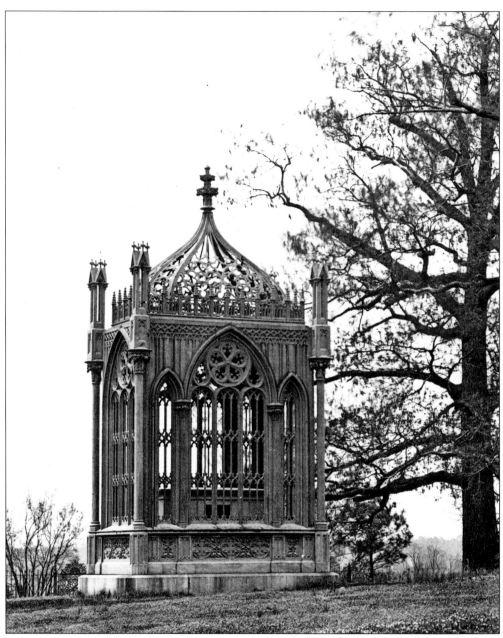

James Monroe, the fifth president of the United States, was interred in New York until 1858, when he was exhumed, and with great pomp and circumstance, his coffin was paraded through New York City and shipped to Virginia. In a tragic twist of fate, a grandson of Alexander Hamilton, the first secretary of the treasury, fell off the boat carrying the coffin and drowned. Monroe and Hamilton nearly had a pistol duel once, and Monroe had sided with Hamilton's enemy, Aaron Burr. Monroe's body was placed in an ornate crypt on one of the higher elevations of Hollywood Cemetery in Richmond. Gov. Henry Wise of Virginia had also wanted to rebury Madison and Jefferson at Hollywood to place the three giants of early Virginia politics at the state capital, but this did not transpire. Elizabeth's remains were brought to rest beside her husband and were placed next to the exterior of his crypt. (LCPP.)

Five

WILLIAM HENRY HARRISON

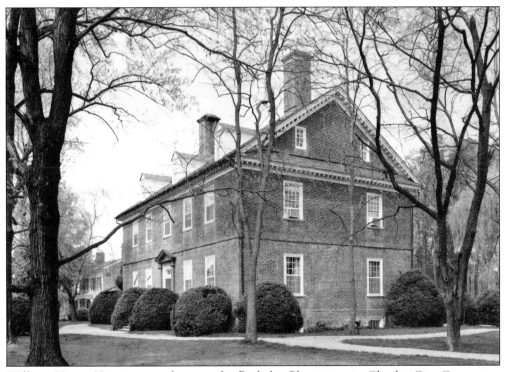

William Henry Harrison was born at the Berkeley Plantation in Charles City County on February 9, 1773, into one of Virginia's earliest leading families. Berkeley was a large three-story brick mansion overlooking the north side of the James River. Early English colonists came ashore near present-day Berkeley on December 4, 1619, and observed what is suggested to be the first official Thanksgiving in America. (HABS/LCPP.)

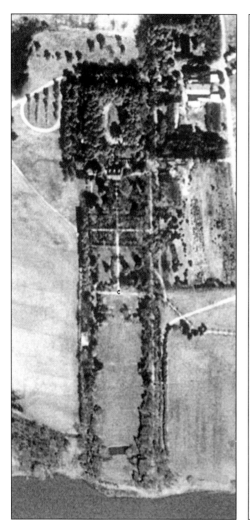
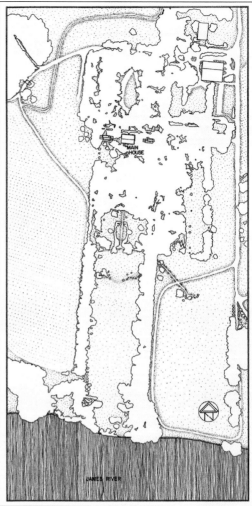

The Charter of Berkeley Hundred specified the thanksgiving service that was to be held once the colonists arrived: "Wee ordaine that the day of our ships arrival at the place assigned for plantacon in the land of Virginia shall be yearly and perpetually kept holy as a day of thanksgiving to Almighty God." Berkeley also touts the claim as the site of the first distillation of bourbon whiskey in 1621, manufactured by a missionary named George Thorpe, who declared it "much better than British ale." Over 100 years later, in 1726, Benjamin Harrison IV built the impressive Berkeley home with large terraced gardens leading down to the river through a long, tree-lined path measuring over a quarter mile in length. The wharf was known as Harrison's Landing, the location of a battle during the American Civil War. (HABS/LCPP.)

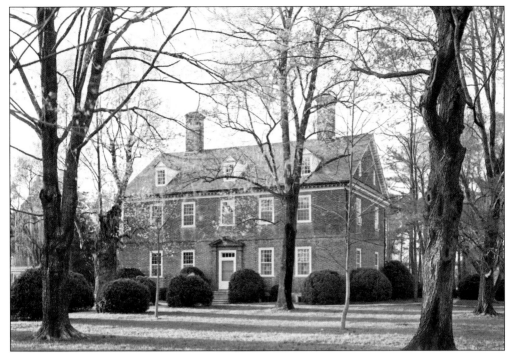

Harrison IV attended the College of William and Mary and represented Charles City County in the House of Burgesses from 1736 to 1742. He was a large landholder and married Anne Carter, daughter of Robert "King" Carter of Shirley Plantation. They had 10 children. Harrison IV and two daughters were killed on July 12, 1744, by a lightning strike at Berkeley and were buried in the family cemetery. (HABS/LCPP.)

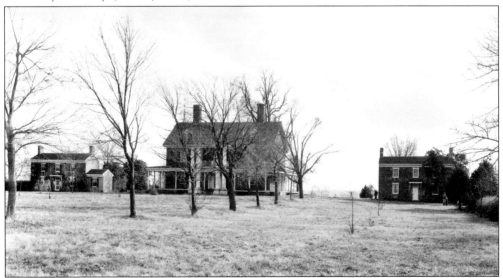

Berkeley passed to Benjamin Harrison V, born in 1726, the year the house was built. Harrison V, like his father, also studied at William and Mary, and upon his father's death, he managed his estate while still studying at school. Harrison V married his second cousin, Elizabeth Bassett. Two large dependencies were built on either side of Berkeley, used for residences and other domestic tasks. (HABS/LCPP.)

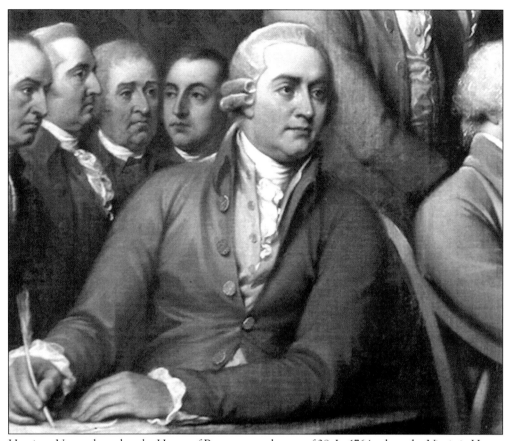

Harrison V was elected to the House of Burgesses at the age of 38. In 1764, when the Virginia House passed the Stamp Act Resolutions, the governor tried to bribe Harrison V with an appointment to the executive council. He refused the appointment, declared a devotion to republican principles instead, and was elected to the Continental Congress in 1774. (LCPP.)

No matter what else Harrison V did in his life, nothing would eclipse his signing of the Declaration of Independence on July 4, 1776. Known forever after as "Benjamin Harrison the Signer," he propelled Berkeley and the Harrisons into a new political spotlight. He is shown at the signing in John Trumbull's famous painting above . He was elected the fifth governor of Virginia in 1781. (LCPP.)

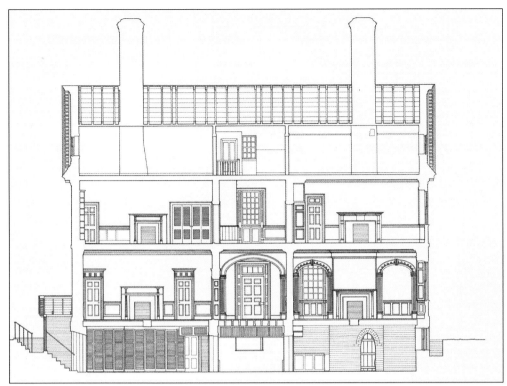

The substantial brick home is, in reality, four stories when the basement is accounted for. Large even by modern standards, the enslaved labor involved in constructing such a large brick structure in 1726 illustrated the prosperity of the Harrison family. Harrison IV's initials appear in a dated stone over one of the doorways of the Georgian mansion, the oldest in Virginia with a pediment roof. (HABS/LCPP.)

The main room and entertaining center for the house was in the east bay of the first floor. A central chimney had two mantels for each side of the room, but no doorways to close them off completely. An exterior kitchen was located to the west (left), with an underground passage from the kitchen allowing servants to bring the food through a whistling corridor. (HABS/LCPP.)

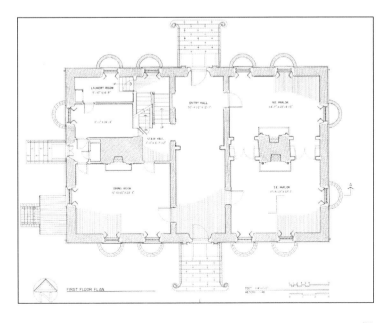

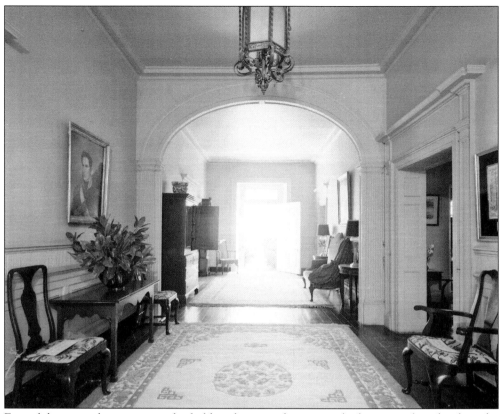

Formal dances and parties were also held in the central passage, which was much wider than the normal Georgian house of the period, as the passage lacked a main stairwell. Family and guests had to use the small stairwell located in the rear of the mansion to get to the upstairs bedrooms. (HABS/LCPP.)

A large interior wooden stairway was added later, still outside the passage and next to the north main entrance, removing portions of one room on each of the three floors. The musicians played on the landing of the stairway, which had an opening to the central passage to allow for the flow of music. (HABS/LCPP.)

The handsome Federal-period woodwork, which was hand-carved by slaves, and the double arches of the main room in the mansion were installed by Harrison VI around 1790, under the direction of Thomas Jefferson. Most of the wood flooring and the majority of the building fabric of Berkeley are original. (HABS/LCPP.)

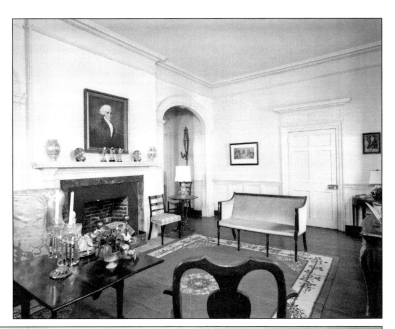

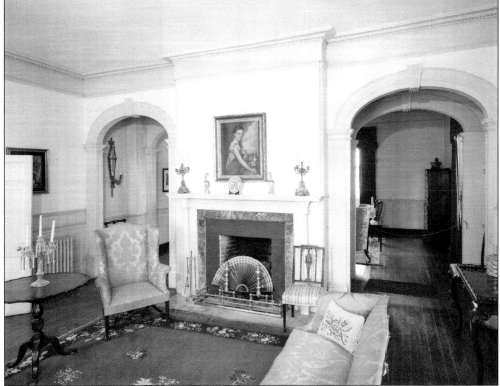

John Jamieson, a Scotsman, bought Berkeley in 1907, wanting to preserve the history of the area. Jamieson served as a drummer boy in the Union army in the area during the Civil War. After he purchased the property and buildings, he spent the next 20 years trying to restore the place. The rooms are furnished with a magnificent collection of 18th-century antiques purchased by the Jamieson family. (HABS/LCPP.)

Jamieson's son, Malcolm, asked for Berkeley as part of his father's estate when he died in 1927. Malcolm and his wife, Grace Eggleston, restored the manor at their own expense, never asking for state or federal assistance. Berkeley had been in deteriorating condition. They purchased many period antiques, including several pieces auctioned from the Westover Plantation. (HABS/LCPP.)

Berkeley lore relates that George Washington and the next nine presidents of the United States all enjoyed the famous hospitality of the Harrisons at Berkeley in this dining room with its view of the James River. While possible, John Adams and John Quincy Adams would have had to travel far from home to get to Berkeley. (HABS/LCPP.)

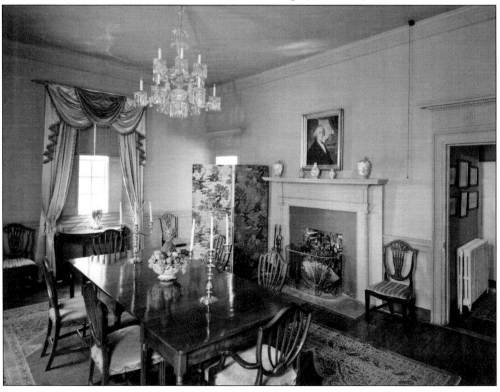

The basement level of Berkeley now serves as both a museum and theater. The 19th-century plaster lathe has been removed to show the underside of the hand-hewn floor joists and original wood planking under the first-floor level. The basement extended under the entirety of the house with walls of hand-molded brick. (HABS/LCPP.)

The main entrance to Berkeley today is on the north side of the home, with a circle drive and long approach from the John Tyler Memorial Highway—the historic road from Williamsburg to Shirley Plantation and west. Richmond was not yet founded in 1726, when Berkeley was built. (HABS/LCPP.)

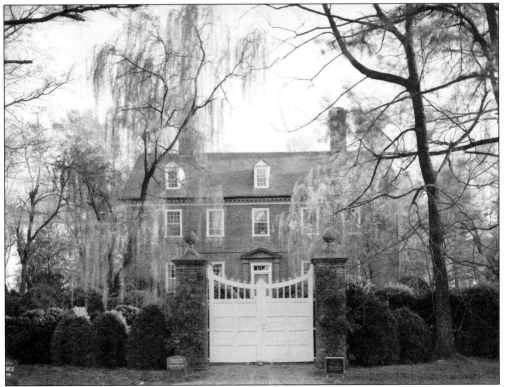

The original approach to the mansion was from the south, directly from Harrison's Landing on the James River along a brick- or shell-lined walk through the terraced gardens. Berkeley's 10 acres of formal terraced boxwood gardens and lawn extend almost a quarter mile from the front door to the James River. (HABS/LCPP.)

The gardens are a favorite of most tour groups and events, including the Fall Foliage Tour in September and Garden Week in the spring. Many of the boxwoods are original to the gardens, dating back to at least the mid-1700s. The original wharf at the river at the terminus of the walkway through the gardens is long gone. (HABS/LCPP.)

William Henry Harrison was born in an upstairs bedroom at Berkeley three years prior to his father's signing of the Declaration of Independence. Young William studied at Hampden-Sydney College and the University of Pennsylvania. Upon his father's death in 1791, Harrison left home and joined the army, where he found fame in the Northwest Territory, becoming governor of the Indiana Territory. He finally settled in North Bend, Ohio. (LC.)

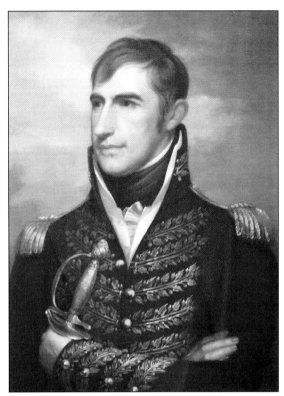

When Harrison left Berkeley as a young man, he corresponded with his siblings, his mother dying a few years later. His parents are buried in the small family cemetery overlooking the river southeast of the mansion. A marker celebrates Benjamin Harrison the Signer, and another marker commemorates all the signers and their families for their bravery in the face of potential imprisonment, hanging, torture, debt, and sickness. (Author.)

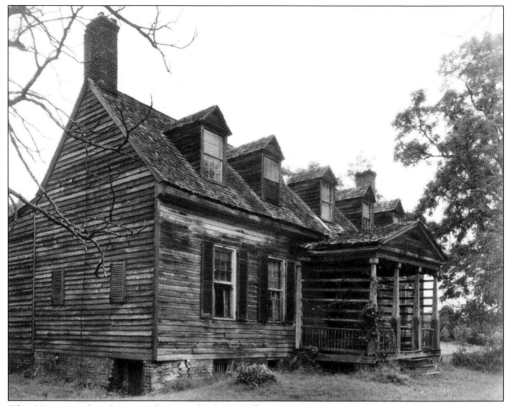

The Harrison family's social status had an influence on another plantation in Charles City County. The Kittiewan Plantation, south of the courthouse, was built by Dr. William Rickman and his wife, Elizabeth Harrison, the oldest sister of William Henry. Originally called Milford by Rickman, the wood-frame structure was rather plain on the exterior, perhaps a negative for the wife of the head of the Continental Army hospitals in Virginia. (KA.)

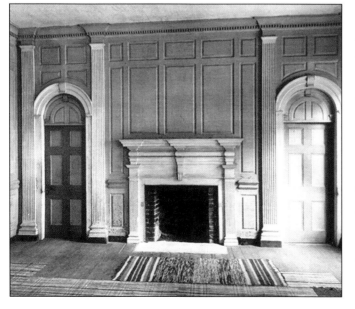

The elaborate raised pine paneling inside the Kittiewan parlor was usually seen in larger period brick homes, such as Salubria in the Germanna Colony. Elizabeth Rickman more than likely desired the paneling, which would allow her to entertain family and friends from Berkeley and reflect her husband's status in the Continental Army. When Elizabeth died, she gave her land to her brothers, Carter Bassett and William Henry Harrison. (KA.)

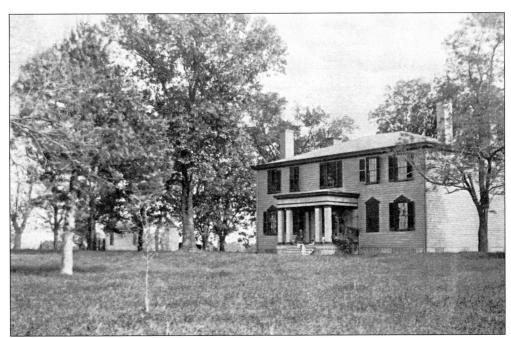

Another Harrison influence was North Bend Plantation, built between 1810 and 1820 on land owned by John Minge and his wife, Sarah Harrison, a sister of William Henry. Their older sister Elizabeth Harrison Rickman had lived next door at the Milford (Kittiewan) Plantation. The home is a Federal-period, Greek Revival–style house named after William's home in Ohio, located on the North Bend of the Ohio River. (RC.)

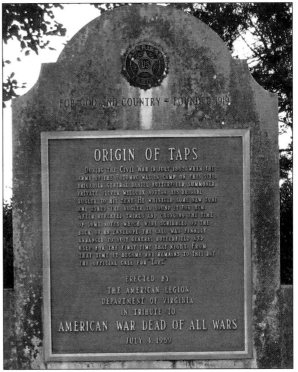

Another significant event occurred at Berkeley during the Civil War. The Army of the Potomac camped there in July 1862. Brig. Gen. Daniel Butterfield summoned his bugler, Pvt. Oliver Norton, and whistled him a tune, asking Norton to sound it back. After repeating the tune scribbled on the back of an envelope, and changing the timing, the tune finally suited Butterfield, and "Taps" was used the first time that evening. (Author.)

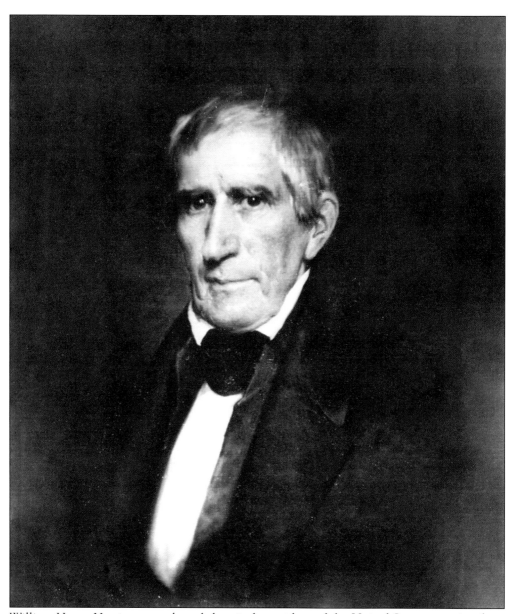

William Henry Harrison was elected the ninth president of the United States, running from Ohio, in December 1840, with fellow Virginia-born neighbor John Tyler as his running mate. Their "Tippecanoe and Tyler Too!" campaign focused on Harrison's rural ties. He returned to Berkeley to write his inaugural address in the room in which he was born. The speech ironically helped summon his death. He was then the oldest person to run for the presidency, which may have contributed to recovery efforts when he caught a cold giving his inauguration speech. Harrison died from the cold after only one month in office and was the first president to die in office. This image of Harrison is thought to be the daguerreotype taken of him close to or on his inauguration day, March 4, 1841, by Justus Moore and Captain Ward. The image is more lifelike than any surviving painting of Harrison. Elements from this image were drafted in most of the ensuing paintings and engravings that followed his death. It is possibly the first-ever presidential photograph. (MOMA.)

Six

JOHN TYLER

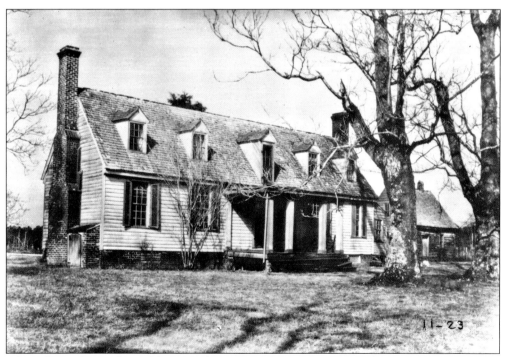

John Tyler, 10th president of the United States, was born at Greenway Plantation in Charles City County on March 29, 1790, the sixth of eight children of Judge John Tyler and Mary Armistead. Both a farmer and a public servant, Judge Tyler built the modest wood-frame manor house around 1776, several years before John was born. The tract contained around 1,060 acres, a substantial landholding for the period. (HABS/LCPP.)

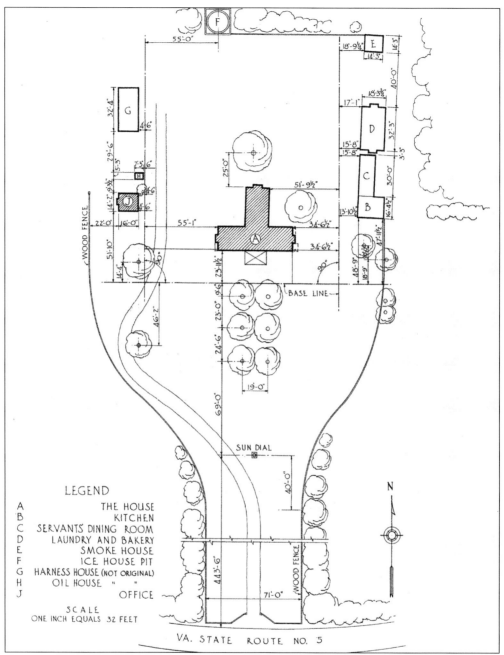

Greenway was designed by Judge Tyler to face the main road from Williamsburg to Richmond, now the John Tyler Memorial Highway. The main house, office, kitchen, and slave quarters were closely grouped, allowing for most domestic activities to occur within close proximity to the manor. Visitors would be able to see all of the outbuildings as they approached the house, giving an impressive first view of the manor. (HABS/LCPP.)

Judge Tyler attended William and Mary's grammar school in Williamsburg when he was eight years old. After he graduated from the college, he also studied law there for five years and became good friends with George Wythe, Thomas Jefferson, and Patrick Henry. In 1772, he opened a law practice in Charles City County. (SFA.)

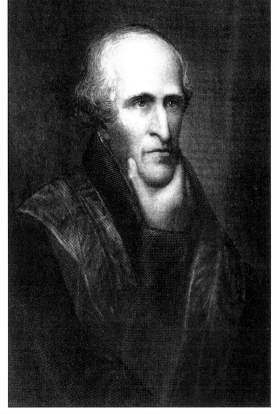

Judge Tyler became a member of the Virginia House of Delegates during the American Revolution, serving until 1786, and was Speaker of the House for five of those years. He was appointed judge for the First Court of Appeals in 1786, serving in that position until 1808. During his delegate tenure, Greenway was built as the Tyler family home. (HABS/LCPP.)

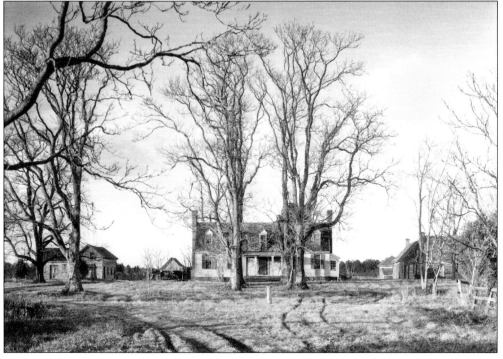

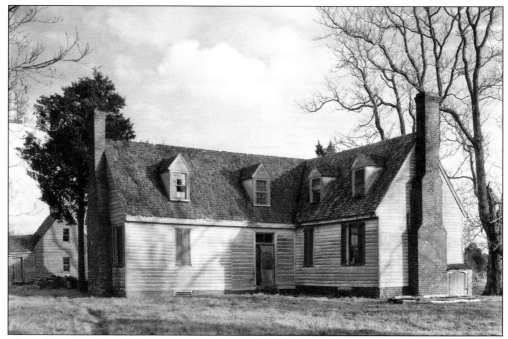

The Tylers were comfortable with their eight children in such a spacious setting and would still have been able to entertain visitors. The later rear addition made the house a T shape. Young John Tyler's mother died when he was only seven years old, and Judge Tyler, then 50 years old, never remarried. His six older sisters no doubt had an influence on his upbringing after their mother's death. (HABS/LCPP.)

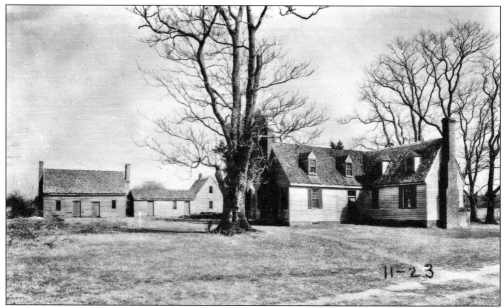

Judge Tyler was elected the 15th governor of Virginia in 1808. During his tenure, the law halting the importation of Africans to the United States for slaves was passed. In 1811, the judge was appointed to the U.S. District Court for the District of Virginia, a post he held until his death. Judge Tyler and Mary are buried in the small cemetery to the rear of Greenway. (HABS/LCPP.)

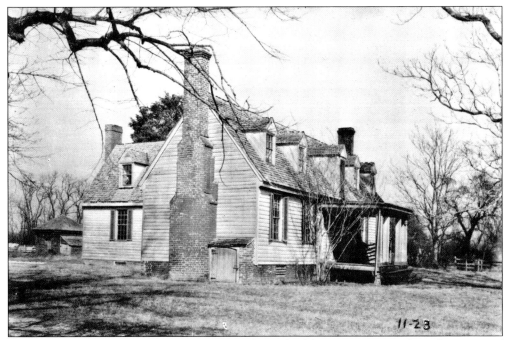

Greenway was situated on the uplands over a mile north of the James River, with no direct view of the water. The main house is a charming example of an early American home for the middle-class planter of the late-18th-century Virginia Tidewater. The house is extremely similar to Kittiewan Plantation, which was built around the same time period a few miles away. Note the exterior cellar entrance near the chimney. (HABS/LCPP.)

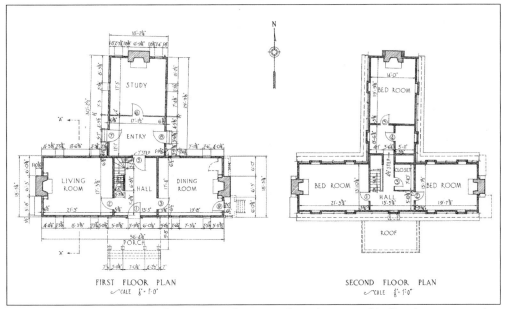

The original section is oriented east to west facing south, with a central hall and rooms on either side both upstairs and down. The home is 1.5 stories, with picturesque dormers on the second level. The rear addition was oriented slightly off from the same axis as the original section. In 1805, Judge Tyler wanted to sell Greenway. (HABS/LCPP.)

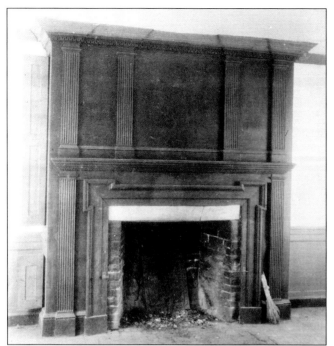

The advertisement for the sale of Greenway in 1805 provided information on the property and buildings. "Greenway contains 500 acres, well improved. On it is a genteel, well finished dwelling house, containing six rooms, all wainscoted chair board high, with fine dry cellars the full length of the house, which is 56 feet." With only six rooms listed, it is possible the rear addition had not yet been added. (HABS/LCPP.)

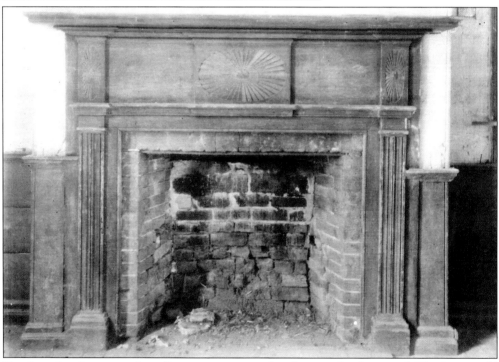

Two large fireplace mantels in Greenway were wood and ornate for the period. The fires would have provided warmth for the large family and house as well as for guests and events. While very similar to the Kittiewan Plantation on the exterior and in the floor plan, the interior walls of Greenway were simply plastered instead of paneled with pine, as seen at Kittiewan. The main kitchen was in the rear addition. (HABS/LCPP.)

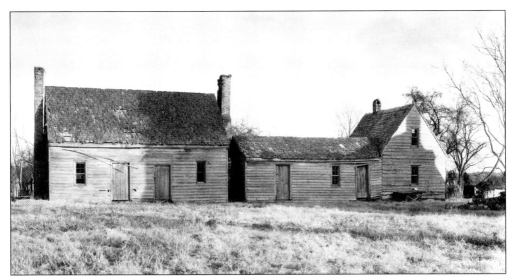

In the 1930s, these three outbuildings were listed, from left to right, as the laundry/bakery, servant's dining room, and slave kitchen. The 1805 advertisement stated the property had "every other building which a reasonable person could wish or desire, including a storehouse, kitchen, laundry, dairy, meat house, spinning house, ice house, barn, two granaries, two carriage houses, quarters for house servants and a handsome octagon pigeon house." (HABS/LCPP.)

This small building was the office at Greenway. When Judge Tyler died in 1813, Greenway was given to son Wat Tyler, who sold it out of the family. John Tyler Jr., the future president, repurchased Greenway in 1821 and lived there while governor with his first wife, Leticia, but sold it before he became president. Greenway and many of the outbuildings still stand today and are privately owned. (HABS/LCPP.)

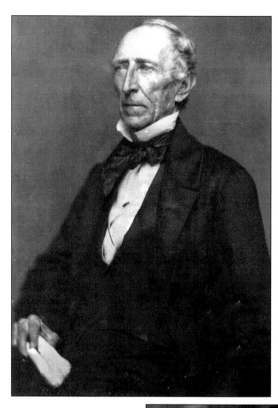

John Tyler loved books, probably due to the influence of his father, Judge Tyler. The young John attended William and Mary at the age of 12 and graduated at 17, about the time his father was elected governor. He studied law, and in 1811, he was elected to the Virginia House of Delegates. In 1816, he was elected to the U.S. Congress, leaving because of ill health in 1821. (LCPP.)

Tyler married Letitia Christian, the daughter of a wealthy planter, on March 19, 1813. She was soft-spoken and preferred to simply be the spouse of her husband rather than participate in the political limelight. John and Letitia had eight children, with only Anne dying as an infant. Letitia followed Tyler through his entire political career, including the presidency, through their long and fruitful 29-year marriage. (SFA.)

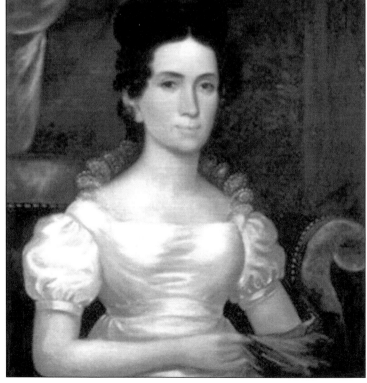

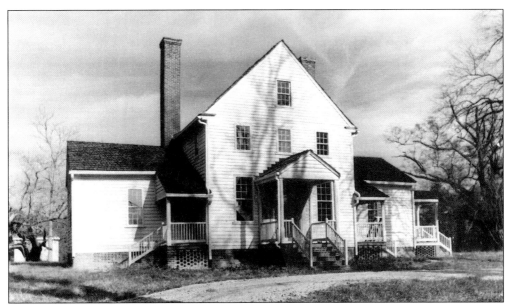

John and Letitia built a modest wood-frame home, named Woodburn, a couple of miles west of Greenway in 1815. Tyler was serving in the District Court, and the couple lived here until 1821, when he repurchased Greenway and they moved back to his birthplace. Tyler never lived at Woodburn long; he sold it in 1831 and briefly bought and sold it again in 1842. (VDHR.)

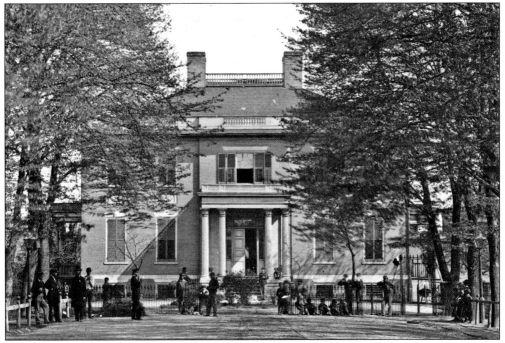

Tyler was elected governor of Virginia in 1825, and the family moved into the governor's mansion in Richmond. Built by 1813, the mansion was located adjacent to the state capitol and is the oldest continuously occupied governor's home in the United States. Tyler was the third governor of Virginia to become president of the United States, following in the footsteps of Thomas Jefferson and James Monroe. (LCPP.)

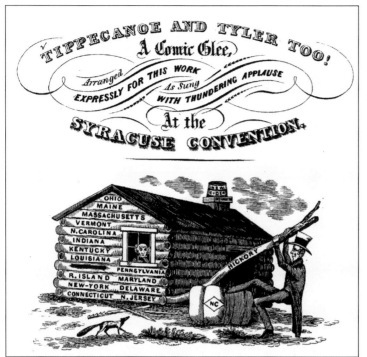

Tyler ran as vice president on the 1840 William Henry Harrison ticket "Tippecanoe and Tyler Too!" and won. Never expecting to be president, Tyler assumed the role when Harrison died in office in April 1841. Letitia had suffered a major stroke in 1838, and she was too incapacitated to serve as the first lady. Her daughter-in-law Priscilla filled the position while Letitia stayed upstairs at the White House. (LCMD.)

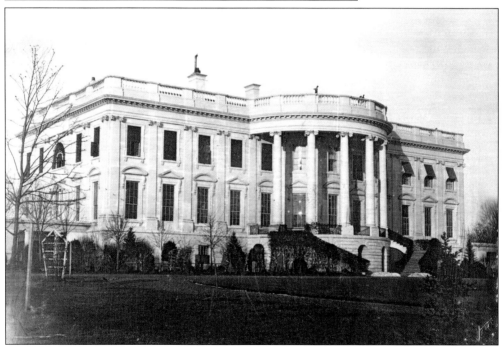

Letitia died on September 10, 1842, in the White House, having only come down to greet the public when her daughter Elizabeth was married there earlier in January. Grief stricken, Tyler continued his presidential duties. He separated from his Whig party and became an unpopular president, still accomplishing a small agenda. His administration was able to annex the Republic of Texas as a state. (LCPP.)

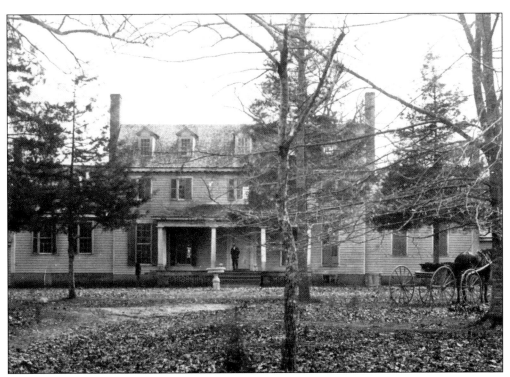

Tyler purchased a mid-18th-century house from Collier Minge in Charles City County in 1842, just before Letitia died. He intended to retire to the peaceful country setting. It was called Walnut Grove because of a row of walnuts on the front lawn, but Tyler renamed the house Sherwood Forest because of his "outlaw" status within his own party. The original front of the house is now the rear. (LVA.)

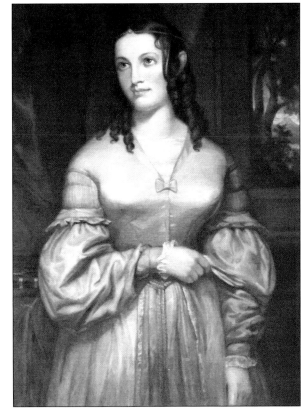

In February 1844, an explosion on the USS *Princeton* killed Secretary of State Abel Upshur, Col. David Gardiner of Long Island, and others. Below deck prior during the explosion were Dolley Madison, President Tyler, and Gardiner's daughter Julia. Tyler wept, and Julia Gardiner fainted, but out of this tragedy came a courtship. Tyler and the 30-year-younger Gardiner were married in a private ceremony on June 26, 1844. (SFA.)

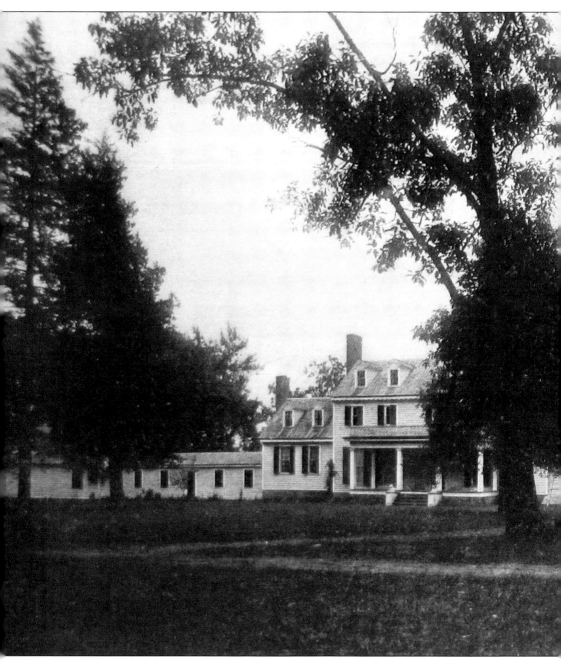

Tyler asked his new wife if she would mind living in the country, as he had just purchased a country home in Charles City County. She was very much in favor of the idea. While the president stayed in Washington, Julia traveled to Sherwood Forest and began planning to renovate and expand the home. While still entertaining her guests at the White House, the young wife immediately started to build two long colonnades on either side of the house, making it even more of an

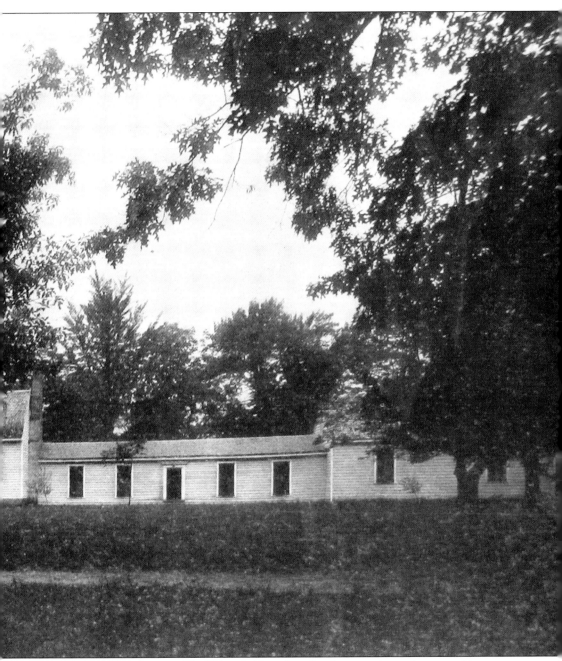

impressive view for the visitor. The Tyler children from his first marriage who were older, many married, did not come to live at Sherwood Forest. The youngest two, Alice and Tazewell, were still living with Tyler and his new bride at the White House, and they came to live at Sherwood Forest when their father left office. Julia and John had seven children themselves, all living to adulthood, bringing the total offspring of the 10th president to 15. (VDHR.)

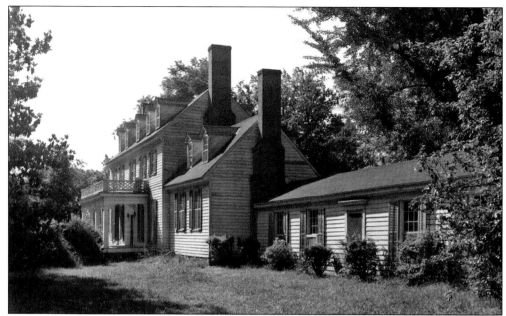

Julia's love of dancing, especially her fondness for the Virginia reel, was the driving force behind the addition of the long colonnades on both sides of Sherwood Forest. The west colonnade, shown here, was used for dancing and connected the main house to an extant law office. (HABS/LCPP.)

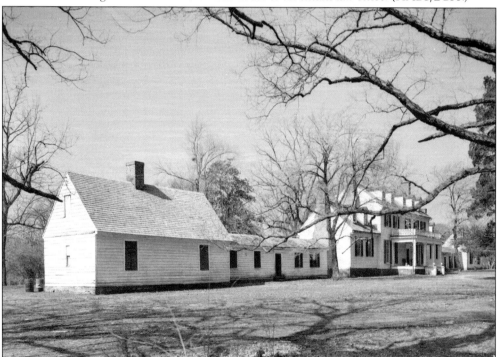

The east colonnade, shown here, connected the main house to a 17th-century kitchen, shown on the left, possibly the oldest surviving example of a kitchen in Virginia. The east colonnade was not used for dancing, and for many years, it simply had shelves for storage; however, the colonnade did provide symmetry for the home. (HABS/LCPP.)

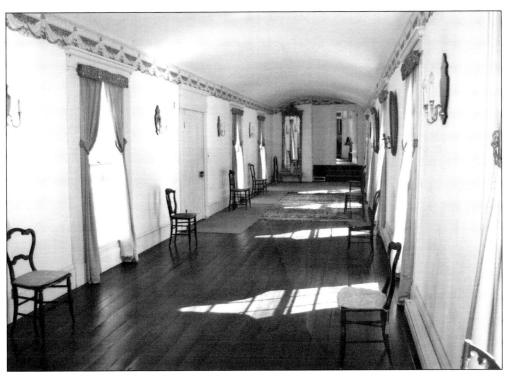

Julia designed the west colonnade with the special intention of dancing her beloved Virginia reel. The 65-foot ballroom was able to accommodate the entire footprint of the dance with enough space for a small band to play the familiar accompanying music. Julia wanted to enhance the ballroom experience even more, so she had the ceiling curved to reflect the music throughout the length of the structure. (Author.)

This view shows the dilapidated east colonnade before it was renovated in the 1970s. Small rooms with modern facilities were added to the east colonnade in the mid-20th century. The addition now serves as a separate apartment to the home for the numerous Tyler family members as well as guests. (HABS/LCPP.)

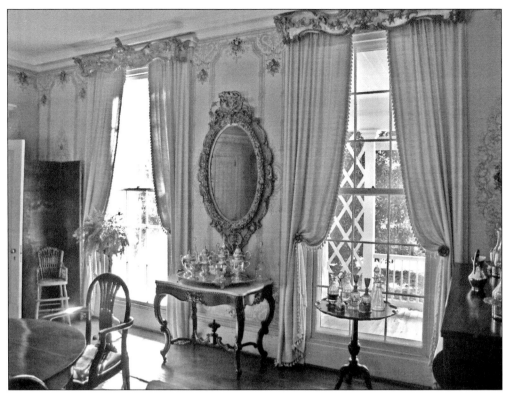

The mirror and marble table were owned by John and Julia and are now part of the Sherwood Forest collection. Julia, even though she agreed to live in the country, did not simply want to give up her national status as a first lady of the United States. When she designed and expanded Sherwood Forest, her tastes were seen throughout the house. (Author.)

Julia had written to her mother about a decorative valance she had seen in an advertisement with angels on the ends. Her mother promptly purchased some for her to place in her new house. Two such fixtures still adorn the windows with a southern exposure in the main dining room. (Author.)

The central staircase leads to the upstairs bedrooms. The entire home is 300 feet in length and only one bay wide, unique across the country. The house is touted as the longest wood-frame structure in the nation and the only historic presidential home still owned by a descendant. (Author.)

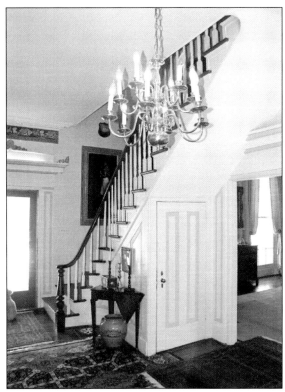

This view is the interior of the original southern entrance of Sherwood Forest. Guests and family members now enter from the north, opposite of this door, after coming up the lane from the John Tyler Memorial Highway. Through this door walked many a politician, as well as friends and family. During the Civil War, many Confederate and Union soldiers also walked through these doors, both with different intents. (Author.)

Gen. George McClellan protected Sherwood Forest from harm in the early months of the war, but the home was not so fortunate as the war progressed. Union soldiers entered at one point to burn the house, placing straw on the floor in the central hallway. Slaves helped put out the fire quickly, with little damage, but the base of this original marble tabletop bears the scars from the fire. (Author.)

The original mantel around the fireplace in the dining room was left intact, but the mantel in the drawing room was removed during the war. Harrison Ruffin Tyler, grandson of the president and Julia, has owned Sherwood Forest since 1975 and has restored the entire building complex, placing many of the family heirlooms back in the manor. Tours are held in the house by appointment. (Author.)

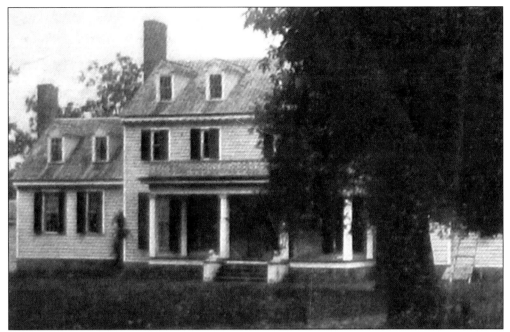

The north side of Sherwood Forest was the rear of the house when the Tylers first moved there in the mid-1840s. Today the approach is a circle at the end of a long tree-lined drive from the highway. The front steps were adorned with a set of solid cast-iron hunting dog statues, a wedding present to John and Julia for their country estate in 1844. (LVA.)

The dogs were at Sherwood Forest almost from the beginning of the Tyler era, seen on both sides of the steps in the historic photograph above. At one point during the Civil War, Union soldiers tried to walk off with the statues. The Tylers found them abandoned in the nearby woods, too heavy to hand-carry any great distance—each weighed almost 500 pounds. (Author.)

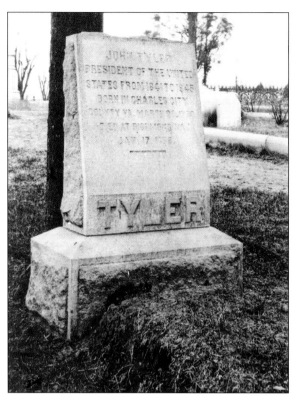

Tyler was elected to the Confederate House of Representatives and went to Richmond in January 1862 to take office. Julia had a horrific dream of him dying in a hotel bed. She quickly came to Richmond and found him alive. The next morning, he woke and went down the hall, where he fell ill. He died on January 18, before taking office. He is buried in Hollywood Cemetery in Richmond. (Author.)

John Tyler, the 10th president, wanted to be buried at Sherwood Forest where four large trees grew near the house. The last of these trees fell in 2007, shown here. Tyler never lost an election in his 41-year political career and was the only president of the United States not to be officially mourned in Washington, having died supporting the Confederacy during the Civil War. (Author.)

Seven

Zachary Taylor

Zachary Taylor, the 12th president of the United States, was born in Orange County on November 24, 1784; his exact birthplace is unknown. His parents owned plantations named Montebello and Hare Forest, and many historians and Taylor family members agree Montebello was the site, just a few miles west of Gordonsville. Above, two men look at the remains of the brick chimney from the probable birthplace at Montebello in 1933. (OCHS.)

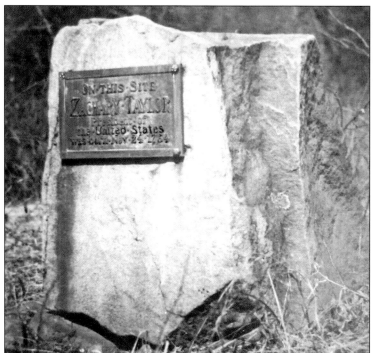

This brass marker anchored on a stone at Hare Forest denoted the possible birthplace of Zachary Taylor, placed by the Daughters of the American Revolution. While the farm was owned by the Taylors at the time of his birth, most historians familiar with the property agree that Taylor was born at Montebello and not at Hare Forest. (VDHR.)

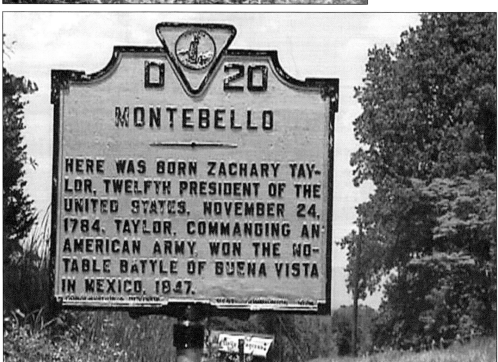

Taylor's parents were in the process of moving to Kentucky but were delayed, and as a result, he was born in Virginia. His father, Richard Taylor, had served during the American Revolution and was a first cousin to James Madison, the fourth president. Most biographies state Zachary Taylor and James Madison were second cousins, a simpler but technically inaccurate relationship. (VDHR.)

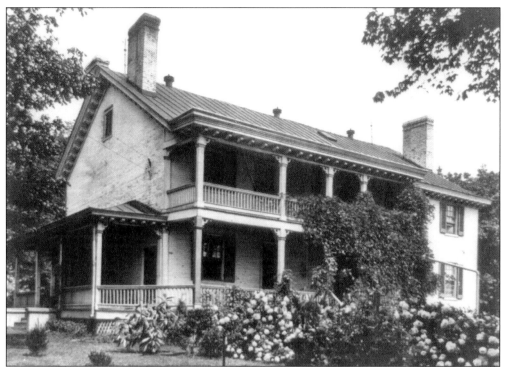

The Taylors lived in a simple log cabin near Louisville, Kentucky, upon their arrival there in 1785 and then built the first portion of this handsome 2.5-story dwelling around 1790. The house is the only non-Virginia residence featured in this book, but it shows what the Taylors might have built in Virginia had they stayed. (LCPP.)

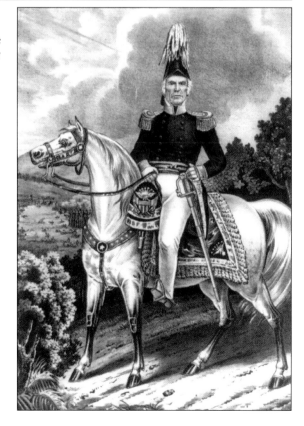

Zachary Taylor left Kentucky and served in the Northwest Territory in the Indian campaigns under William Henry Harrison, the War of 1812, the Black Hawk War, and the Second Seminole War, where he gained the nickname "Old Rough and Ready." In 1845, Taylor defended Texas during the war with Mexico, achieving many victories. (LCPP.)

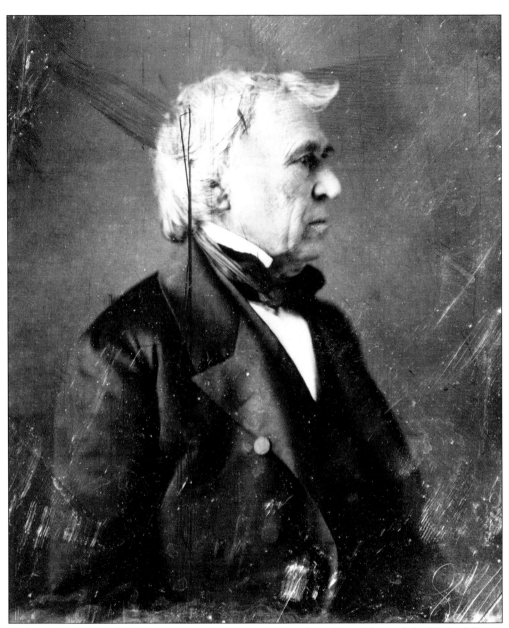

Zachary Taylor was the first career military man to be elected president of the United States and the first president not previously elected to any public office. Despite being a slaveholder, he opposed extending slavery into the California and New Mexico territories and threatened to use military force against secessionists to preserve the Union. As President Taylor was enjoying the Independence Day celebrations in Washington on July 4, 1850, it has been said he consumed a snack of milk and cherries, along with several other dishes presented to him by well-wishing citizens. Later that evening, he developed nausea and other symptoms. Worsening each day, the president died on July 9; the cause listed was gastroenteritis. Taylor was the second president to die in office. William Henry Harrison, the first president to die in office, like Taylor, was also Virginia-born. Fellow Virginia-born presidents Thomas Jefferson and James Monroe had died on July 4 in 1826 and 1831 respectively, and Taylor became fatally ill on July 4, 1850. (LCPP.)

Eight

THOMAS WOODROW WILSON

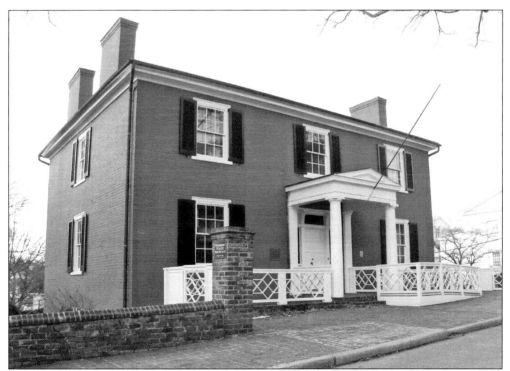

Thomas Woodrow Wilson was born on December 28, 1856, in the manse (parsonage) of the Staunton Presbyterian Church in Staunton, Virginia. Called "Tommy" during the majority of his youth, he was just over a year old when his family moved to Augusta, Georgia. During his teens, they moved to Columbia, South Carolina. Many people are surprised to learn the 28th president spent most of his youth in a southern setting. (Author.)

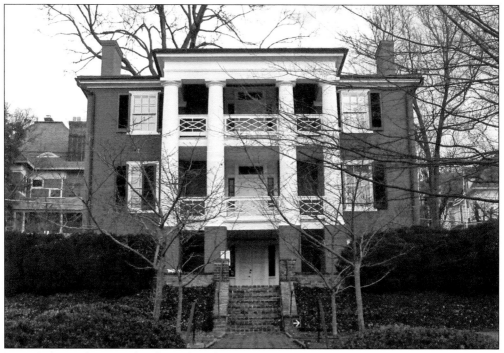

In 1845, the Presbyterian church purchased several lots to build the manse. The church appropriated funds to build the house, and the church ladies group held a fair raising $300. The handsome manse may have been designed by the Reverend Rufus Bailey, founder of Augusta Female Seminary and designer of its classical main building in 1844. The manse and the college's old building are strikingly similar in style. (Author.)

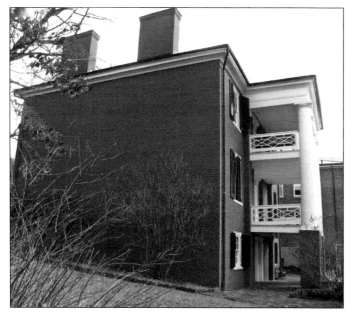

John Fifer built the brick manse. His son John Wilson Fifer (later governor of Illinois) remembered that some of the construction workers left to become soldiers in the Mexican-American War. The renovated manse stands on a hill overlooking what is now Staunton's Gospel Hill Historic District. The three-story pillared rear porches were a predominant landmark seen not only from the Presbyterian church across the street, but also throughout the surrounding neighborhood. (Author.)

The Reverend Benjamin Smith and family lived in the manse from 1847 until 1854. The Reverend Joseph Ruggles Wilson, a professor at Hampden-Sydney College, accepted the pastoral position in 1854. Reverend Wilson and his wife, Jessie, shown here, moved into the manse in early 1855 with their daughters Marion and Annie. The third Wilson child was born in December 1856 and was named for his maternal grandfather, Thomas Woodrow. (WWPL.)

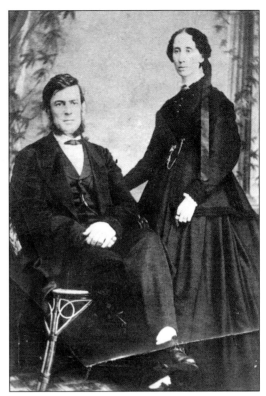

The main entrance woodwork has been restored to a faux wood grain appearance, typical for the period, where the grain has been painted to resemble a more expensive wood type. Through this door, the visitors and members of the congregation were greeted by the Wilsons. The house has been renovated and refurbished to give the appearance of a mid-19th-century house with many of the Wilson family artifacts. (Author.)

This guitar was owned and played by Wilson's mother, Jennie, an accomplished musician. Music and education played a large role in the lives of the Wilson parents, helping create role models for their children. Reverend Wilson had been both a pastor and a teacher of chemistry and natural philosophy prior to moving to Staunton. He also served as principal of the Augusta Female Seminary in Staunton in 1855 and 1856. (Author.)

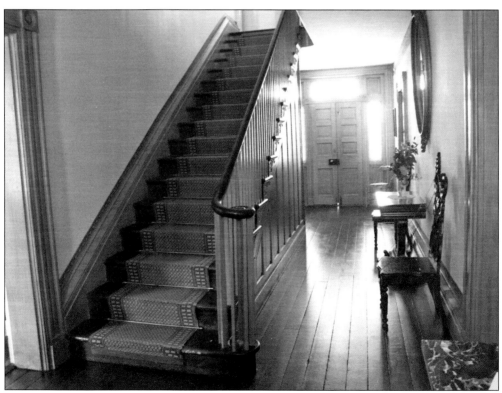

This elegant wooden staircase is located in the hallway just inside the front entrance, where young Wilson's two sisters and overnight guests went up to their bedrooms. The family might have also used some of the rooms for a study or storage, since the family was much smaller than the number of rooms in the house. (Author.)

The master bedroom in the manse is located on the first floor with good sunlight during the cold winter months. The actual Wilson bed where little Tommy was born just after Christmas in 1856 is shown with a chamber pot under the bed. As typical of the period, a midwife would have been present to help the mother deliver while the father waited expectantly in a nearby room. (Author.)

Wilson's baby bed is one of the prized possessions of the Woodrow Wilson Presidential Library and Museum. Wilson spent much of his life in Staunton in this small bed in the master bedroom next to his parent's bed. Just over one year old when they moved, Wilson may have not yet outgrown this bed. (Author.)

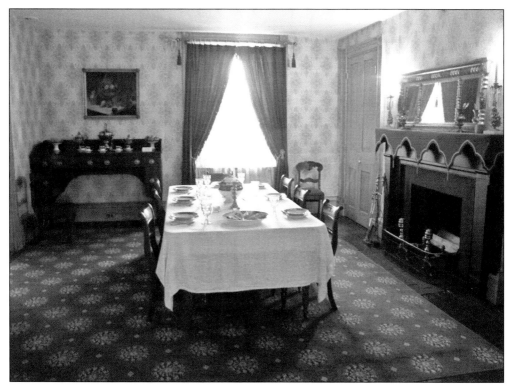

The main dining room for the adults is situated on the entrance floor. The large fireplace kept the room warm and cozy for entertaining. Servants would have brought the food from the kitchen in the lower level of the house. Reverend Wilson's church could be clearly seen through the window. (Author.)

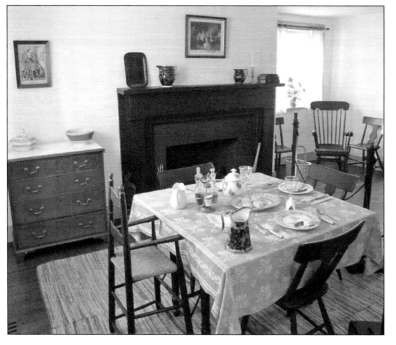

The spacious children's dining area was located on the lower level of the manse, where Wilson and his sisters ate all of their meals. His sisters may have also studied in the room, as Wilson was still an infant when they lived there. The children typically ate at another location separate from the adults unless it was a special occasion. (Author.)

Servant quarters were nestled between the children's dining area and the kitchen on the lower level of the house. Reverend Wilson's family does not appear to have owned slaves, but slaves were used as cooks and servants in the manse, provided either by the church directly or by members of the congregation. (Author.)

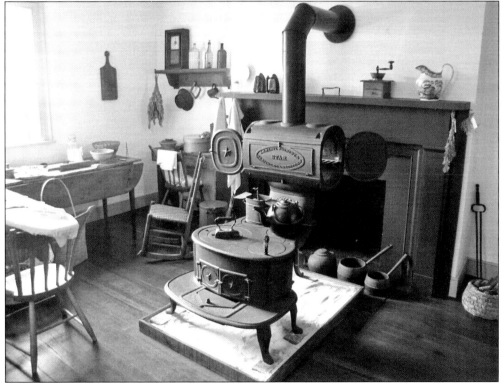

The kitchen is situated on the lower floor, where water could easily be brought in from a well in the backyard, supplies could be brought in through a rear entrance, and heat from the cooking could contribute to the warmth of the lower level. The laundry and ironing were also performed in the kitchen. (Author.)

The bathing and storage area was below street level in a portion of the house with no windows at the time. Only four ministers' families occupied the manse following the Wilsons. Wilson returned to Staunton many times during his childhood to visit his aunt, Marion Woodrow Bones, and family, but he never visited the manse. His sisters and several cousins attended the Augusta Female Seminary in Staunton. (Author.)

A new Presbyterian church building was built on the same side of the street as the manse, across the street from the earlier building, in 1870. The white four-columned rear portico of the manse can be seen peeking over the roof of the new church just to the right of the steeple. (WWPL.)

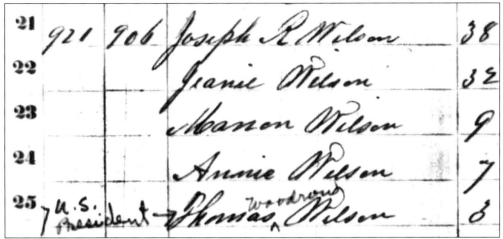

The Wilson family appeared for the first time together in the 1860 Population Census for Richmond, Georgia, just after they moved from Staunton. Someone reviewing the records could not help but graffiti the original record with the news that three-year-old Thomas Wilson became the leader of the United States. (LC.)

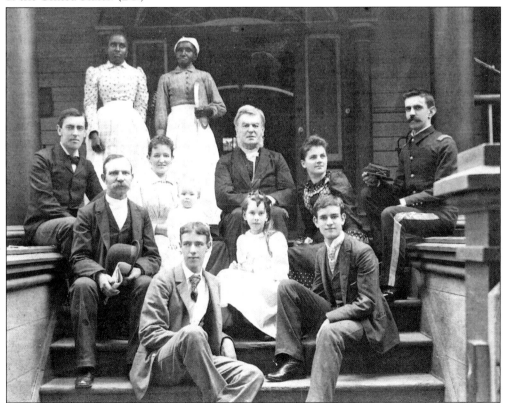

Young Wilson, shown here on the far left, graduated from the College of New Jersey (Princeton University) and started using his middle name, Woodrow, when he was studying law at the University of Virginia in 1879. He became a professor and then the president of Princeton in 1902. While serving as governor of New Jersey, Wilson was elected as president of the United States on November 5, 1912. (WWPL.)

The City of Staunton
cordially invites you to be present
on Saturday December the twenty-eighth
nineteen hundred and twelve
and participate in the welcome
extended to the
Honorable Woodrow Wilson
President-elect of the United States
on the occasion of his visit
to the place of his birth
Staunton, Virginia

Staunton wanted to show the newly elected president they were proud of their native son, and a huge celebration was held just after Christmas 1912. President-elect Wilson returned to Staunton to celebrate his 56th birthday on December 28 in the manse where he was born. (WWPL.)

Even though it was the second decade of the 20th century, Wilson arrived at his birthplace in a horse-drawn carriage, as not too many automobiles were available to the average population. Wilson, shown in a hat in the carriage, was elated to be given such a royal reception in Staunton. (WWPL.)

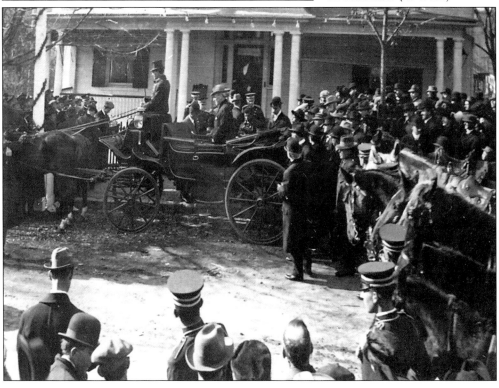

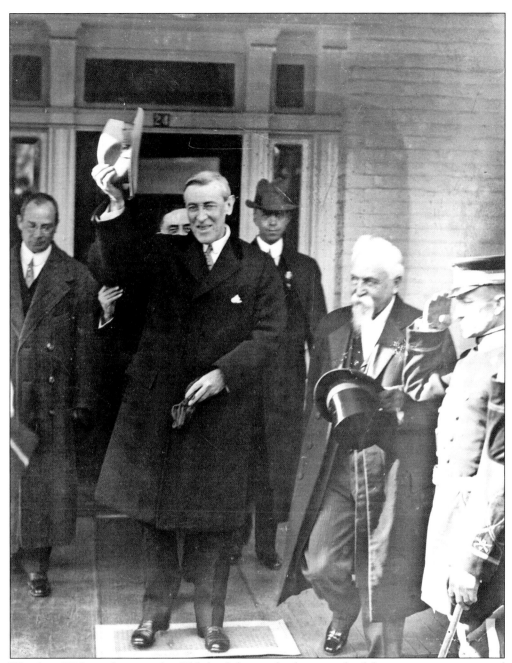

Woodrow Wilson, shown on his 56th birthday on the front porch of the manse, never returned to Staunton. His two terms of office included the death of his first wife, remarriage, World War I, and the establishment of the League of Nations. Suffering from ill health from a stroke in office, Wilson died in 1924. The Presbyterian church sold the manse to Mary Baldwin College for a memorial. (WWPL.)

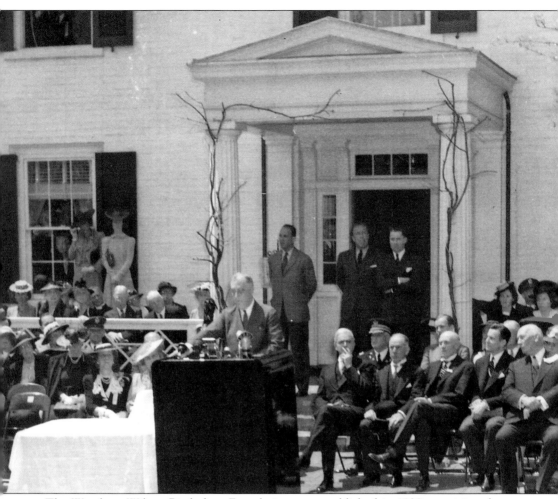

The Woodrow Wilson Birthplace Foundation was established in 1938, acquiring the manse and property, followed by a complete restoration of the home by 1941. In May 1941, six months before the beginning of World War II, Pres. Franklin Roosevelt visited the restored manse and called it a "shrine to freedom" in reference to Wilson and his resolve to end the Great War and establish the League of Nations. Today the manse is open to the public and a major part of the Woodrow Wilson Presidential Library and Museum system, showing the family, community, and political life of the Thomas Woodrow Wilson family. (WWPL.)

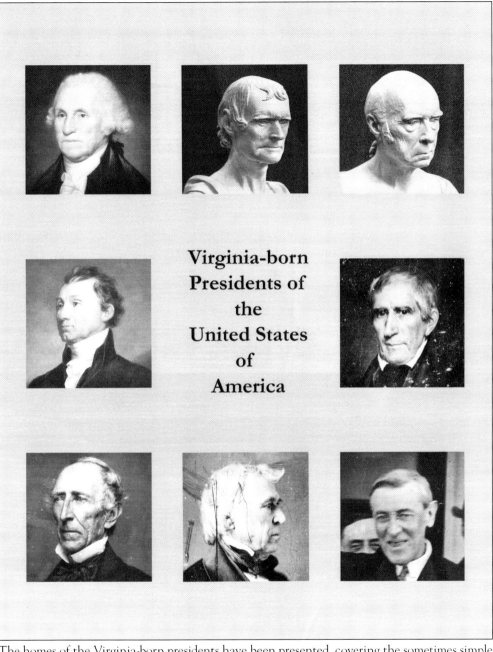

Virginia-born Presidents of the United States of America

The homes of the Virginia-born presidents have been presented, covering the sometimes simple and many times lavish and elegant homes of these men who were the leaders of our country. From Founding Fathers to an Ivy League university president and from war heroes to a farmer, they were from all walks of life. Through paintings, life and death masks, photographs, drawings, and archaeological investigations, their histories and legacies will survive the test of time. (Author.)

Birthplaces and major residences

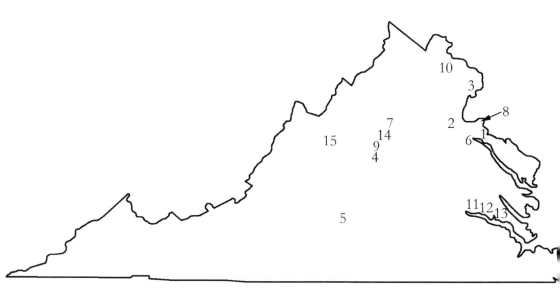

1 - Pope's Creek - Washington
2 - Ferry Farm - Washington
3 - Mount Vernon - Washington
4 - Shadwell and Monticello - Jefferson
5 - Poplar Forest - Jefferson
6 - Belle Grove - Madison
7 - Montpelier - Madison
8 - Monroe birthlace - Monroe
9 - Highlands - Monroe

10 - Oakhill - Monroe
11 - Berkeley - Harrison
12 - Green Spring and Woodburn - Tyler
13 - Sherwood Forest - Tyler
14 - Montebello - Taylor
15 - Staunton Manse - Wilson

This map illustrates the locations of all the homes serving as residences for the Virginia-born presidents in this book. (Author.)

ABBREVIATIONS

AND CREDITS

Author	Taken by Patrick O'Neill
GWBNM	George Washington Birthplace National Monument, National Park Service
GWF	The George Washington Foundation, Fredericksburg, Virginia
GWFLB	The George Washington Foundation, Fredericksburg, Virginia, L. H. Barker © 2008, All rights reserved
HABS/LCPP	Historic Architectural Building Survey records at the Prints and Photographs Division, Library of Congress
HF	Painting by John Gadsby Chapman, 1833; Homeland Foundation, Amenia, New York
JMMF	James Monroe Memorial Foundation
KA	Kittiewan Plantation archives, Charles City, Virginia
LB	Leslie Barker
LC	Library of Congress
LCMD	Music Division, Library of Congress
LCPP	Prints and Photographs Division, Library of Congress
LVA	Special Collections, Library of Virginia, Richmond, Virginia
MF	The Montpelier Foundation, Orange, Virginia
MFMRMW	Matt Reeves and Mark Wenger, the Montpelier Foundation, Orange, Virginia
MFKW	Kenneth W. Wyner, the Montpelier Foundation
MFLBM	Linda Boudreax Montgomery, the Montpelier Foundation
MFPI	The Montpelier Foundation and Partsense, Inc.
MOMA	Museum of Modern Art, New York City, New York
OCHS	Orange County Historical Society, Orange, Virginia
NPG	National Portrait Gallery, Washington, D.C.
RC	Ridgely and the late George F. Copland, owners of North Bend Plantation
SFA	Sherwood Forest archives
TJF	Thomas Jefferson Foundation
USM	U.S. Mint
VDHR	Virginia Department of Historic Resources, Richmond, Virginia
WWPL	Woodrow Wilson Presidential Library, Staunton, Virginia

DISCOVER THOUSANDS OF LOCAL HISTORY BOOKS
FEATURING MILLIONS OF VINTAGE IMAGES

Arcadia Publishing, the leading local history publisher in the United States, is committed to making history accessible and meaningful through publishing books that celebrate and preserve the heritage of America's people and places.

Find more books like this at
www.arcadiapublishing.com

Search for your hometown history, your old stomping grounds, and even your favorite sports team.

Consistent with our mission to preserve history on a local level, this book was printed in South Carolina on American-made paper and manufactured entirely in the United States. Products carrying the accredited Forest Stewardship Council (FSC) label are printed on 100 percent FSC-certified paper.

MADE IN THE